D0254955

Remarkable Women

of the

NEW JERSEY SHORE

Clam Shuckers, Social Reformers *and* Summer Sojourners

Karen L. Schnitzspahn

THE
History
PRESS

Published by The History Press
Charleston, SC 29403
www.historypress.net

Copyright © 2015 by Karen L. Schnitzspahn
All rights reserved

First published 2015

Manufactured in the United States

ISBN 978.1.62619.682.7

Library of Congress Control Number: 2014954498

Notice: The information in this book is true and complete to the best of our knowledge. It is offered without guarantee on the part of the author or The History Press. The author and The History Press disclaim all liability in connection with the use of this book.

All rights reserved. No part of this book may be reproduced or transmitted in any form whatsoever without prior written permission from the publisher except in the case of brief quotations embodied in critical articles and reviews.

In memory of my grandmother Ruth Hunt (1895–1973). She loved the New Jersey Shore and vacationed at Margate and Atlantic City for over forty summers. The classic "Jersey girl," Ruth was born in Bloomfield and lived in South River for most of her life. A devoted wife, mother and grandmother, she was also a talented pianist, artist and assistant to her small-town medical doctor husband (my grandfather). The first woman elected to the South River Board of Education, she participated in many civic affairs. Ruth was also a champion trap shooter, fondly called the "Annie Oakley of New Jersey." My "Gramma Ruth" was a remarkable woman!

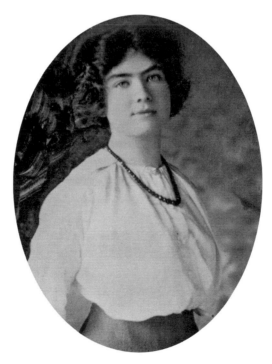

The author's grandmother Ruth Hunt, circa 1915.
Author's collection.

CONTENTS

ACKNOWLEDGEMENTS

Researching and writing about these remarkable women has been a pleasure. So many people, both women and men, have assisted me during the course of this project. Sandra Epstein, my good friend, coauthor of *Belmar: Volume II* (Arcadia, 1999) and fellow history sleuth, has been especially helpful. Thank you, Sandy.

Many thanks to these authors who have provided me with information and encouragement: Dave Bryceson, Feather Schwartz Foster, Michael "Spike" Fowler, Randall Gabrielan, Gordon Hesse and Vicki Gold Levi. I admire the works of these talented writers. And I'm forever inspired by the indomitable spirit of my friend and mentor, the eminent author and historian George H. Moss Jr. (1923–2009).

Sincere thanks to the following individuals and organizations: Suzanne Kaufer Spencer, Doris Pflug Jernee and Mary Ann La Regina, Erik Larsen of the *Asbury Park Press*, Kathy Skouras and the Wildwood Historical Society, Jim Stephens of Historic Cold Spring Village, Susan Laudeman, J.P. Hand, Royston Scott, Kathy Ferris Heim and the Point Pleasant Historical Society, Sandy Hook (Gateway National Recreation Area) historian Tom Hoffman, Sharon Patterson, Dell O'Hara and the Ocean Grove Historical Society, Jaclyn Stewart Wood of the Tuckerton Seaport & Baymen's Museum, Jeff McGranahan and the Ocean City Historical Museum, Heather Perez of the Atlantic City Free Public Library and a very special thank-you to Patti Scialfa. There are countless others who have helped along the way, and I appreciate each and every one of them.

ACKNOWLEDGEMENTS

Special thanks to Whitney Landis of The History Press, who is always so patient and knowledgeable. Also, thank you to Dani McGrath of The History Press for her kindness and encouragement.

I'm blessed to have a talented and loving family. I'm thankful for my son Doug; his wife, Radha (both outstanding writers and editors); and their beautiful children, Isa and Kieran. I'm grateful for my professor son Greg (aka "Max") and appreciate his suggestions. A big shout-out to my husband, Leon, for his love and tech support, especially at those times when I start yelling, "Help! I think my computer is crashing!" And I'm thankful for Yoshi, a wonderful dog who gives unconditional love to his entire family.

WOMEN BY THE EDGE OF THE SEA

All of the women featured in this book have been touched by the sea, in particular by the Atlantic Ocean along the New Jersey coast from Sandy Hook to Cape May. Their stories unfold from the time before colonization of the area to the present day. Some are famous; some are not. Each one of them has been influenced by the shore and has made an impact on the area. These remarkable women have felt the warm sand beneath their feet, splashed in the waves and basked in the sun. And they have also experienced hardships and the devastation of storms.

Many spunky nineteenth-century women hiked up their long skirts and pitched in to do dirty work. Often, when their husbands died, wives had to take over traditionally male jobs out of necessity. On the other hand, Victorian ladies of leisure wore white gloves as they sipped tea on their oceanfront piazzas. There are women who were born near the sea and those who relocated from cities. Their reasons for living at the New Jersey Shore are wide ranging: for their health, to start a business, to raise a family or simply to escape the heat. There were women who toiled in rustic huts shucking clams and those who sweated in bogs picking cranberries. A number of women worked on their family farms, some operated boardinghouses and others were performers who entertained the tourists. Each one of these diverse women is remarkable, and each one has a story to tell.

When I began to write a book about New Jersey Shore women, I became overwhelmed. So many names came to my attention. As I delved into the research, the list grew and grew! There was no way I could possibly include

all of them, so I decided to stick to a narrow geographic parameter. I've included a selection of women who either lived full time or summered along New Jersey's 127-mile Atlantic coast.

At first, my idea was to write only about women from the distant past. But there were some contemporary women I wanted to include, so I interspersed the text with a few modern stories. There are thousands who deserve recognition, but the space limitation of this book didn't allow them all. I was determined to represent various walks of life. I made a selection, but there are many more stories to be told.

The history of women overall in New Jersey is a vast topic. The state has such a rich history and has been home to an abundance of great female leaders, reformers, inventors, writers and entertainers. Then there are those "ordinary" women, their names unrecorded, who've worked to make the Garden State a great state. At the New Jersey Shore, women were an influential force long before the summer cottages, hotels and boardwalks were built.

NATIVE AMERICANS AND COLONISTS

Native Americans of the Lenape nation were the first people to live along the New Jersey coast. Most of the seashore was wilderness before resort towns were developed in the mid-1800s. It's not certain how many Native Americans lived year-round on the coast or came only in the summer. Either way, they no doubt enjoyed eating shellfish, gathering wild berries and cooling off in the surf. Lenape women allegedly shared responsibilities with the men, including planting, harvesting, childcare, preparing food and weaving baskets. Author David D. Oxenford explained the position of the women in their culture, stating that they lived in a matrilineal society. According to Oxenford, the Lenapes' "inherited power was passed on through the woman's clan. The women would select the men who would exert the actual legislative power and handle relations with other tribes."[1]

Not much information is available about the earliest European women to settle along the New Jersey coast. The story of Penelope Stout is based on truth but has become a popular tale passed down in the oral tradition and, later, in writing. Around 1643, a small Dutch sailing ship ran aground near Sandy Hook, New Jersey, after crossing the Atlantic. All of the voyagers got to shore safely and decided to make their way to New Amsterdam. Among

them was a young Dutch couple who stayed behind because the man was feeling ill. The couple, alone and defenseless, was attacked by Indians, who murdered Penelope's husband and left her for dead. Though badly injured, she managed to stay alive and hid inside a hollow tree. But two Indians found her days later. One of them captured her alive. Supposedly flinging her over his shoulder, he carried her to the area that's now Middletown, New Jersey. (This account seems to fit with the derogatory stereotype of Native Americans that was perpetuated during the nineteenth and early twentieth centuries.)

It wasn't until sometime later that the Dutch in New Amsterdam heard about a white woman living with Indians. They figured it must be Penelope. When they found her, they brought her back to the city. She married an Englishman named Richard Stout. The couple moved to the Middletown, New Jersey area, where they lived and farmed the land. Penelope and Richard had ten children, and there are said to be over five hundred direct descendants. Penelope reportedly lived to the ripe old age of 110.[2]

During the Revolutionary War, two sisters, Rebecca and Sarah Stillwell, were said to have proved their heroism. They lived at Beesley's Point, Cape May County. In the fall of 1777, Rebecca spotted British gunboats on the south shore of Egg Harbor Bay. She knew the British must be after the salt and other supplies that were stored nearby. Her husband, Captain James Willetts, and most of the local men were away fighting, so she decided to do something on her own. Rebecca set off the only cannon available, which had been loaded in case of an attack. She managed to scare the British so that they retreated and sailed away. Her sister, Sarah, was also a heroine who saved her husband, Captain Moses Griffing. He had been captured by the British and was being held on a prison ship in New York Harbor. Sarah supposedly walked one hundred miles on a dangerous trek from Beesley's Point to North Jersey. General Washington gave her an escort to visit the British, and she was able to save her husband's life by arranging for a prisoner exchange.[3]

During colonial times and into the early nineteenth century, most women worked at home. At the small farms and fishing villages that dotted the Jersey coast, women were responsible for taking care of the children and doing domestic chores. They did the gardening and farming, as well as the sewing, spinning, laundering and cooking. Women milked the cows, churned the butter and preserved foods. The children were often recruited to help with these tasks. Women also cared for the sick and delivered babies, as there were few doctors. It was common for women to maintain herb gardens and make their own medicines.

MOVERS AND SHAKERS

After the Civil War, more women began to work outside the home. The rise of industrialization created jobs for women in factories, retail stores and offices. However, they were usually subjugated to low-level positions. At the New Jersey Shore, there were very few factories. Most jobs for women were seasonal ones as agricultural workers and clam shuckers or as maids, cooks and laundresses in wealthy homes and hotels. There was an increased need for teachers, and a number of women secured work in education.

During the late nineteenth century, women gained influence in New Jersey with the formation of clubs and charitable organizations. Previously, they had been involved mainly with religious groups and church activities. As women found themselves with more leisure time, they also had the opportunity to establish clubs, which heightened their prominence in society. By the close of the nineteenth century, both white and black women had formed political, civic and cultural clubs. The New Jersey State Federation of Women's Clubs, a volunteer organization founded in 1894, is still active today. Charities, including those to aid orphaned and abused children and societies for the welfare of animals, were largely supported by women. Women's political causes, primarily campaigns to promote temperance and achieve suffrage, were well represented along the Jersey coast.

In regard to women's suffrage, New Jersey has an active history. When the state was controlled by the Dutch, women had many privileges not found in other colonies. However, the position of women changed considerably when the British took over, and they had less influence. Immediately after 1776, voting rights were granted for all "free inhabitants" who met certain requirements for owning property. Single and widowed women who held property were able to vote, thanks to what might be called a loophole in the system. But in 1807, the state legislature denied women the vote. Their privileges were not restored until the Nineteenth Amendment to the Constitution was passed in 1920, extending suffrage to women.

A name that stands out prominently in the history of women's suffrage in New Jersey is Alice Paul (1885–1977), who was born in Moorestown (Mount Laurel), New Jersey, and grew up as a Quaker. The Quakers had considerable respect for women and recognized their equality to a great extent. During the first decade of the twentieth century, Paul became a champion of the campaign to pass the Nineteenth Amendment. Alice Paul is a remarkable figure in New Jersey history, but she is not included in this volume because she did not live on the coast. For more about Alice Paul, see www.alicepaul.org.

From Bustles to Bikinis

Images of women at New Jersey Shore resorts during the Victorian era often depict willowy young ladies wearing dresses with bustles and plumed hats and carrying parasols. The subjects in Winslow Homer's paintings and engravings of Long Branch from the nineteenth century portrayed mostly well-heeled women. *Long Branch, New Jersey*, Homer's 1869 painting of ladies on the bluff, is arguably the most famous image of that city. It's a stunning piece of work but certainly not representative of average women at the time.

Bathing customs and styles changed drastically from the creation of New Jersey Shore resorts in the mid-1800s to the carefree styles and attitudes of the twenty-first century. In the early days of the seashore resorts, the sexes were segregated, and flags indicated separate times for men or women to bathe in the surf. A red flag meant that the men could enter the surf, and a white flag was the signal that ladies could bathe. However, these rules were abandoned by the late 1800s.

Victorian bathing costumes were usually made of wool. Imagine wearing an itchy wool suit and stockings in humid, ninety-degree weather! At first, bathing suits were makeshift outfits, and some bathers even wore regular

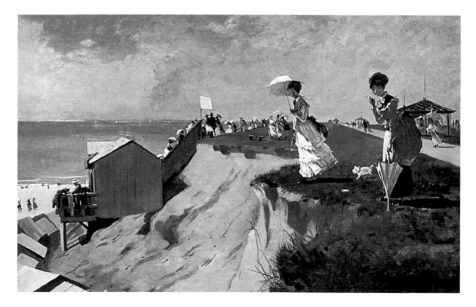

Long Branch, New Jersey, an 1869 oil painting by Winslow Homer. The original work belongs to the Boston Museum of Fine Arts. *Wikimedia Commons.*

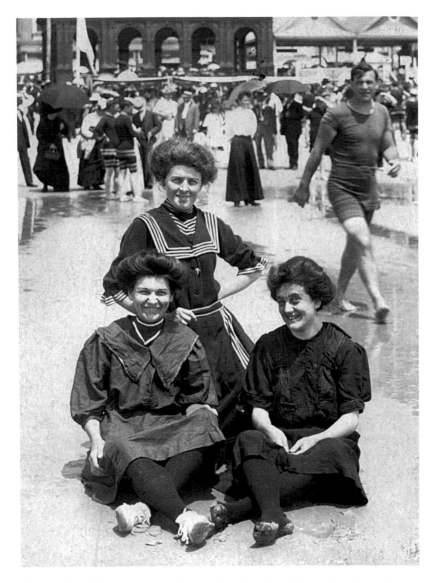

Three unidentified women enjoying the beach in their chic wool bathing suits, Atlantic City, 1908. *Author's collection.*

clothes into the water. But fashionable bathing suits became available to those who could afford them. The July 13, 1872 *Harper's Bazaar* reported on the latest styles for the seaside: "Woolen fabrics and India goods are chosen for sea-shore dresses. Among these are goats' hair, pongee, foulard, and the twilled serge-like flannels, light goods with enough body for warmth, and

pure unmixed stuffs that will not cockle when exposed to dampness. Dresses of all-wool grenadine that have become limp are said to be improved and stiffened when worn in the salt sea air."

Beach styles didn't change a whole lot until after World War I. In the 1920s, women had won the right to vote, and more jobs were becoming available to them. Along with a new morality, clothing styles became far more revealing. Many women were working and had some of their own money to spend on fashions. By the mid-1920s, flappers in cloche hats and short, boyish dresses who drank illegal cocktails, smoked cigarettes and drove automobiles represented the "modern" woman. Along the Jersey coast, which had plenty of bootlegging and rumrunning, speakeasies were easy to find during Prohibition, as both men and women were drinking illegally.

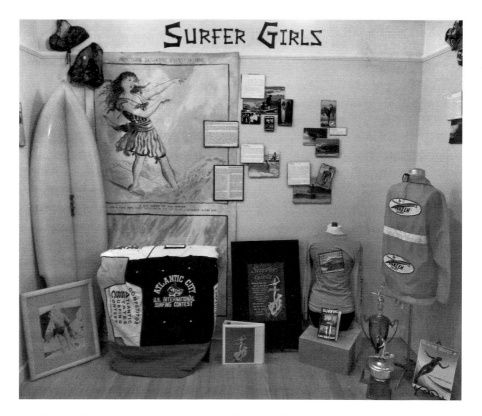

The "Surfer Girls" exhibit at the Tuckerton Seaport & Baymen's Museum. This exhibit details the history of female surfers at the Jersey Shore from an 1888 *Police Gazette* tale of an exotic surfer at Asbury Park to the rise of the sport for women during the late twentieth century through today. *Photo by author, 2014.*

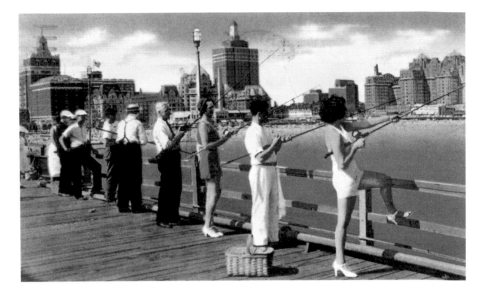

Women have enjoyed fishing at the Jersey Shore since Victorian times. This 1940s Atlantic City postcard features pinup types fishing, but in the 1950s, women fished in more practical clothing. Today, angling is a popular pastime for both women and men. *Author's collection.*

Although clothing became less restrictive, two-piece bathing suits were still not acceptable. However, women started to roll down their stockings to show off their legs! Special officers were hired as "censors" to measure the length of beach attire. Those whose suits were too short or too revealing were asked to leave or even ticketed. Beauty contests with swimsuit competitions proved to be popular events for attracting tourists to New Jersey Shore resorts. As fashions became more comfortable over time, women participated in traditionally male athletic activities, such as swimming, fishing, sailing, scuba diving, water-skiing and surfing.

After the Great Depression and during the war years of the 1940s, women became increasingly daring and provocative. "Pinup" girls were seen everywhere, and two-piece bathing suits were allowed. Curvy beauties appeared on magazine covers, calendars and souvenirs and were even painted on the noses of military airplanes. Of course, just as not every Victorian woman fit the image of Homer's subjects, not every woman of these times resembled a beauty queen or pinup girl.

In 1946, the bikini was introduced in France and soon became trendy at the Jersey Shore. These new, scanty bathing suits revealed the belly button, which had been taboo on the beaches previously. It wasn't only women's fashions that changed, however. Men had to wear tops with

A late 1940s postcard with illustrations of glamorous pinup girls at Atlantic City. *Author's collection.*

their bathing suits until around 1940. Some Jersey Shore towns and boardwalks do have dress codes today, but casual and skimpier clothing is usually acceptable. Tattoos, once frowned on for women, are common today for both men and women. Tattoo businesses are thriving at locations on the Jersey Shore.

The history of women and fashion is fascinating. I could go on about this, but now I'd like you to read my stories about a selection of amazing women. I'm thankful for the opportunity to write about some remarkable women of the New Jersey Shore. I was born and raised in New Jersey, and I've spent a great deal of time at our shore. I really don't find anything derogatory about being called a "Jersey girl" or a "Jersey Shore girl." In fact, I rather like it!

As a teenager in the 1960s, I watched the "feminist movement" take shape, and I've witnessed the growth and progress that has been made over the past half century. Women's history is a complicated topic. There are many types of feminism, with new terms and concepts evolving all the time. This book aims only to tell a variety of stories about women relevant to the New Jersey Shore and preserve them for posterity.

I hope you'll enjoy reading about this diverse group of women. During this journey, I've made new friends and discovered people and places I didn't

know about before. The spirit of the women from the past and the energy of those in the present are strong forces. If I had to choose one word to describe the women in this book, it would be "inspirational." Thank you to all of them!

Chapter 1

Coastal Workers

Clam Shuckers

Although they didn't go out on commercial boats, women were important to the shellfish industry, as they performed the essential task of shucking. In Gustav Kobbé's 1889 classic guidebook, *The New Jersey Coast and Pines*, he writes, "A number of the Parkertown (former name for the village of Highlands) women and girls tread for clams, but as a rule the female element of the settlement is engaged in opening and stringing clams." Throughout the nineteenth and into the twentieth centuries, it was mostly skilled women who removed the succulent mollusks from their shells. While fashionable ladies with parasols strolled on boardwalks at coastal resorts, hearty women labored in waterfront shanties. For Highlands, the clamming industry was the lifeblood of its residents. According to Kobbé, clamming was to Highlands as whaling was to Nantucket. "Clam" was "the first word lisped" by local babies. The shuckers were paid by the piece, and the clams were packed in barrels with ice and shipped to New York City.[4]

These sturdy Bayshore women were usually up before the crack of dawn—and even earlier if the clams had been collected late the day before. The workweek and specific hours varied depending on the times of the catch, usually three or four weekdays and sometimes Sundays to prepare for the big Monday fish market in the city. Some women with school-age children were able to see them off in the morning and then go to work and return when the kids got home. The work was tough, but the women

did have some flexibility.[5] Though their job was exhausting, the shuckers enjoyed some pleasant moments. Margaret Kendrick began shucking in the mid-1920s when she was sixteen years old and stayed with it until the age of thirty-four. She later reminisced about the competitive spirit of the women: "We'd get jealous if one of the girls got much ahead of the rest of us, although one woman in our shanty always had to open the most or she'd be upset, so we let her."[6] Considering that they were being paid according to the number of clams they shucked, this was quite a kind gesture.

To avoid boredom and combat fatigue, the women would joke with one another. According to Margaret, "Somebody'd say something foolish, and we'd all laugh."[7] Occasionally, a man strummed his guitar to entertain them or someone would bring pie and coffee. It was a hard-knock life, but it did have some advantages, especially during times when it was tough for women to find any decent-paying jobs.

If women worked as seafarers along the Jersey coast, their experiences do not seem to be documented. Going out to sea on fishing boats was not an option. In the nineteenth and early twentieth centuries, women were expected to hold down the fort and take care of the shucking and packing. Although they were probably capable of performing most duties of seagoing men, they were not accepted in these jobs. Nevertheless, it's possible that some adventurous women might have accompanied their husbands, fathers or brothers on fishing excursions. By the 1960s, women were occasionally hired to work on fishing party boats and other recreational vessels. Women employed in the seafood industry today mainly perform various jobs such as sorting and packing. There are probably a small number of women who work on commercial boats, a number that might increase in time.

SOME BARNEGAT BAY WOMEN

Long before the development of the Barnegat Bay marshland and Long Beach Island, the local residents relied on the bounty from the sea. The clamming and fishing businesses kept them busy. Scattered boardinghouses opened up for the occasional tourists in the early nineteenth century but were gradually replaced by hotels and summer rentals. The women who lived and worked in this area of Ocean County in the early days fit the description of "hale and hearty" Jersey girls.

Ann Maxon (1833–1898) helped her father run a tavern and sportsman's club on Ocean County's untamed coast. One of the most memorable events in Ann's life was a shipwreck that occurred near her home when she was a teenager. On a bone-chilling day in January 1850, the *Ayrshire*, which was bringing Irish immigrants to the New World, ran aground in a blinding snowstorm. The Francis life-car, a marvelous new piece of equipment, was used in the rescue. A rope line was attached from shore to ship. Only one person died, and over two hundred were saved. Ann's father was later honored for his heroism during this rescue effort.

Ann married Bill Chadwick, and the couple transformed her father's rustic sportsmen's club into a comfortable boardinghouse they called the Chadwick House. Bill was active in the lifesaving service, so Ann took over most of the responsibility of running their inn. She prepared foods from their adjacent farm and became known for her good cooking. Celebrity guests were said to stop at the Chadwick House, including Ulysses S. Grant and Teddy Roosevelt. Six of Ann and Bill's ten children lived to be adults, and Ann died at the age of sixty-five.[8]

Leah Arvilla "Sis" Horner Marr was one of the sturdy Barnegat Bay women who pitched in to help men with their hard work. Born in Tuckerton in 1911, Sis Marr lived above her father's grocery store and went to both elementary and high school in Tuckerton. Sis and her family were full-time seashore people, enjoying swimming at Sea Haven in the summer and ice-skating on Tuckerton Lake in the winter. She married a bayman and dredge operator named Belford Taylor Allan. With him, she hauled in clams from the dredge and from his boat. Then she'd help with sorting and selling them. Besides her ability to work in the rugged atmosphere of the local seafood industry, Sis had a special talent for taking photographs. She and her family chronicled the bay area and, perhaps most significantly, Tucker's Island. The island no longer exists; it was the victim of storms and erosion. In 1927, the island's lighthouse fell into the sea. A wonderful replica of the Tucker's Island Lighthouse serves as an ongoing exhibit space at the Tuckerton Seaport & Baymen's Museum. Sis Marr died in the 1990s, but her photos live on, providing important documentation. Sis was awarded the highly regarded Hurley Conklin Award in 1995.[9]

Several other women have been awarded the Hurley Conklin Award, including those who used their sewing skills to become expert sail makers. Carolyn Chadwick worked for Mr. Perrine, the famous builder of Barnegat Bay sneakboxes (a type of Jersey Shore wooden boat that was used for sailing and duck hunting). Carolyn learned how to make sails from Perrine, whose

The view from the lighthouse (a re-creation of the Tucker Island Lighthouse that fell into the sea in 1927) at the Tuckerton Seaport & Baymen's Museum in 2014. *Photo by author.*

Barnegat boat business was in operation from 1900 to 1956. A re-creation of Perrine's Boat Works is located at the Tuckerton Seaport & Baymen's Museum. Lorna Chadwick Shinn, another award winner, was also a talented sail maker who even made a prototype of a sail wing for windmills for Princeton University. Her first husband, Allen Chadwick, had worked for Mr. Perrine and inherited his sneakbox business.

Wanda Parsons (1927–2014) was the beloved matriarch of the Parsonses' Tuckerton seafood business. "It was a whole family affair,"[10] said Wanda. She was born in Pennsylvania but moved to Tuckerton when she was a toddler. Her uncle who lived and worked in the Barnegat Bay area had written to her father, David Chilcoate, a struggling coal miner, encouraging him to move to the Jersey Shore. In the Barnegat area, he could find a better life with an abundance of clams and good people. So Chilcoate packed up everything he owned and moved his family to Tuckerton. He soon began work as a clammer for Parsons Clams, a thriving retail and wholesale business that supplied clams to the Campbell's soup company.

While attending Tuckerton High School, Wanda and John Mathis "Jack" Parsons were sweethearts. Jack was the son of E. Walter Parsons, who purchased a clam business that began in 1909 from Daniel Mathis. Parsons married Daniel's daughter, Sara. After high school, Wanda trained as a nurse at West Jersey Hospital in Camden, and Jack went into the U.S. Merchant

Marines. Wanda and Jack kept in close touch and married in 1948. Their son Dale was born the following year, and another son was born fifteen months later. Jack worked with the family business, and Wanda was a stay-at-home mom while the kids were young but always helped with the seafood. She worked for thirty-five years as a school nurse at Southern Regional School District. But even during that time, she assisted whenever possible with the seafood store, doing just about everything—except the shucking! She did bookkeeping and personnel work, waited on customers and did whatever was needed. And Wanda wasn't just good at selling clams; she also knew how to cook them! Her family and local residents recall her delicious homemade recipes such as her clam pic and clam stew.

In 2013, both Wanda Parsons and her son Dale Parsons received the esteemed Hurley Conklin Award. Jack, who was also a winner of the award, died in 2009. Wanda died in July 2014 at the age of eighty-six. Dale continues to operate his parents' mom-and-pop seafood business and will eventually turn it over to his son. The clams are mostly farm raised today, but it is hoped that the natural clam beds in the Barnegat area will recover.

Yet another remarkable woman of the Barnegat Bay area was Josephine Lehman Thomas. Born in Michigan in 1898, she worked in Washington, D.C., during World War I. Josephine landed a job as a "government girl," a pioneering position for a young woman. After the war, she was a writer and researcher for famous travel author and radio host Lowell Thomas. Josephine

Wanda Parsons's Clam Stew

Courtesy of Parsons Seafood and Tuckerton Seaport & Baymen's Museum

25 large clams
1 quart half-and-half
1 large can evaporated milk
6 tablespoons butter
paprika as garnish

Drain clams, reserving the clam juice, and mince in a food processor. Place clams in a large pot and cook only until the edges are curly (just a few minutes). Remove from heat. In the meantime, in another pot, heat half-and-half, evaporated milk and butter until the milk is scalded and the butter melted. Remove from heat and add milk mixture to the clams. Do not put back on the heat, otherwise the milk will curdle. Serve hot in bowls and sprinkle with paprika.

enjoyed an adventurous and glamorous life in the Roaring Twenties, but her life changed when she married Reynold Thomas (no relation to Lowell) in 1931. She moved to Long Beach Island (LBI) and adapted to a simpler way of living. Her husband worked as a commercial fisherman and later ran a dredging business. Jo kept writing as much as possible, and in 1933, her beautiful story "Fisherman's Wife" was published in *Scribner's*. It was the Depression, and she had two children to take care of. She had to do the cooking and housework. She didn't have much time for writing, but she always wrote "in spirit."

For many years, Josephine edited and wrote for a seasonal LBI newspaper, the *Beachcomber*. Her daughter, Margaret Thomas Buchholz, took over as editor from 1955 to 1987. Margaret is a well-known Jersey Shore author who maintains her family home at Harvey Cedars on LBI. She is author or coauthor of several books, including *Great Storms of the Jersey Shore*. Buchholz also penned an exceptional biography/memoir of her mother, *Josephine: From Washington Working Girl to Fisherman's Wife*, which was published in 2012.

LIGHTHOUSE KEEPERS

A lighthouse keeper is often depicted as a salty-looking, mustached man wearing a uniform and cap, ascending the spiral staircase of a light tower. But this stereotype was not always true. Now, picture a woman with her hair pulled back in a bun. She is wearing a long skirt and a lace-trimmed blouse with a high collar as she makes her way up those winding steps. Although the keeper jobs were held mainly by men, women filled these positions, too. Beginning in 1883, the male keepers had to wear uniforms, which were never required for the women.

Working at the demanding and often lonely job of being a keeper was not always by choice. There were times when women needed to take over for their deceased or incapacitated husbands. Also, "assistant keepers" were often women who helped their spouses. Though unusual, there were women appointed by the Lighthouse Board to be in charge of the beacons. According to the U.S. Coast Guard, positions as lighthouse keepers were some of the first nonclerical government jobs open to women. But even if they were not given an official title, keeper's wives and daughters often pitched in and helped with the work whenever they were needed.

From the mid-nineteenth to the mid-twentieth centuries, dozens of women manned lighthouses all along the Atlantic and Gulf coasts, and several women are known to have been keepers at the New Jersey Shore. Perhaps the best-known keeper in the New York–New Jersey gateway area was Katherine "Kate" Walker, a German immigrant. She married a sea captain named John Walker, who was assistant keeper at the Sandy Hook Light. John taught Kate to speak English and instructed her in the duties of maintaining a light while he was at Sandy Hook. Soon after they were married, John was appointed as head keeper of Robbins Reef Light (Lower New York Bay), an extremely isolated beacon.

The petite Kate Walker was less than five feet tall and weighed about one hundred pounds. She retired after working as the head keeper at Robbins Reef lighthouse from 1894 to 1919. She had replaced her husband after he died. "Mind the light, Katie," John Walker's dying words to his wife, are often quoted and give a sense of how women were expected to carry on their husbands' work.

Sandy Hook's Lady of the Light: Sarah Patterson Johnson

"I get homesick on Sunday, for I think of you all going to church while I can only look at sand and water (at Sandy Hook) but I suppose I shall not always stay here."[11]

Sarah Patterson was born on February 29, 1832, in Howell Township, New Jersey. She married James L. Johnson in 1856, and they had two children, both of whom died as infants. On May 27, 1864, a century after the Sandy Hook lighthouse was built, Sarah Patterson Johnson became the official assistant keeper. Recently widowed, her new role in life would be to assist her brother, head keeper Charles Patterson, with the rigorous duties of maintaining the lighthouse. Most likely, her brother recommended her for the job. Her salary for her government-appointed job was $360 a year, an amount that sounds funny today but was quite an accomplishment for a woman at that time.

In 1885, when Sarah's brother resigned due to health problems, Sarah also relinquished her position. He died the following year. Sarah took a job as an elementary school teacher at the U.S. Army Sandy Hook Proving Grounds public school, where she instructed the children of army and civilian personnel. She was employed there until 1898 and the start of the Spanish-American War, when civilians were not permitted at the

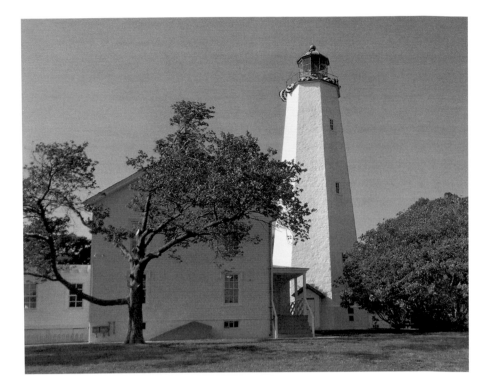

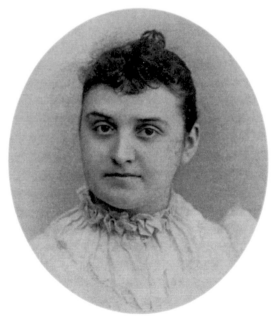

Above: The Sandy Hook Light and Keeper's House at Gateway National Recreation Area, Sandy Hook. The Sandy Hook Light is the oldest standing and oldest operating lighthouse in the United States. Of the eleven lighthouses built in the colonial period (1716–71), it is the only one surviving. The lighthouse celebrated its 250th anniversary in 2014 . *Photo by author.*

Left: Sarah Patterson Johnson, assistant lighthouse keeper at Sandy Hook Light, in her younger days, circa 1870s. *Courtesy of Sharon Patterson.*

base. For the rest of her life, she would live at her Howell farm home, dying there in 1909.

Mary T. Rasa, former National Park ranger and museum curator at Sandy Hook, became interested in the Patterson family during the time she was working there (2003–09). She "was excited to learn that there was a female lighthouse keeper at Sandy Hook" and wrote about her findings. With great gusto, Rasa delved into Sarah's correspondences, which revealed fascinating details about mid-nineteenth-century life. In her will, Sarah requested that her letters be destroyed, but somehow they survived. That might not have pleased Sarah, but it is fortunate because they give such wonderful insight into her life and the history of Sandy Hook.[12]

Sarah Patterson Johnson is included on the New Jersey Women's Heritage Trail. She would probably be surprised to learn how well known she is today; for Sarah, it was all in a day's work. According to Rasa, "She was a remarkable woman serving in both a traditional role as schoolteacher and a non-traditional role of lighthouse keeper."[13]

Many stories of women who helped to man the beacons along the New Jersey coast remain untold, perhaps yet to be discovered in dusty letters or diaries. One lighthouse with a well-documented and fascinating history of women who played important roles is the Sea Girt Lighthouse, which dates back to the late nineteenth century. The hardworking ladies of the Sea Girt Lighthouse included Harriet Yates, "mother and pioneer," who became acting keeper in 1910 after her husband died suddenly from a heart attack. Bill Dunn's excellent book *Sea Girt Lighthouse: The Community Beacon* (The History Press, 2014) tells the full story of this lighthouse, which is a popular site for visitors today.

CRANBERRY PICKERS AND SORTERS

From the time of the earliest settlers, most women along the Jersey coast worked on their small family farms. The farmers' wives and children helped to plant and harvest crops of tomatoes, corn, beans and more. They tended to livestock, especially chickens, pigs, sheep and goats.

Some women worked at agricultural jobs outside the home, for which they were paid very little. From the late nineteenth to the early twentieth century, profitable cranberry bogs were located on the Jersey coast, where seasonal employees picked and sorted the berries. The industry depended on these

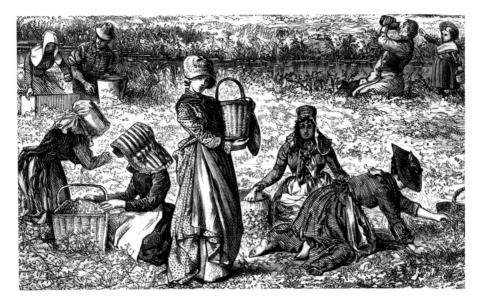

Women working as seasonal cranberry pickers near Tuckerton, Ocean County. Detail from an illustration in *Harper's Weekly*, November 10, 1877. *Author's collection.*

laborers, many of whom were recent immigrants and/or women. The bogs at West Creek, near Tuckerton, yielded luscious cranberries. The dry method of harvesting was used; wet harvesting was not in use until the 1960s.

By the mid-twentieth century, most of the cranberry industry was located farther inland, where bogs were also prevalent. The Pinelands produces both cranberries and blueberries, which were first cultivated by Elizabeth Coleman White at Whitesbog. Elizabeth's life is chronicled in numerous books and articles about women's history, but her story is not included in this work only because the focus is on women who lived or summered directly along the coast. Whitesbog, now preserved by the Whitesbog Foundation Trust (www.whitesbog.org), is farther inland, in Burlington County.

CAPE MAY MITT MAKERS

In Cape May County, during the eighteenth and nineteenth centuries, a garment industry of sorts kept some enterprising women busy. These women produced worsted wool mittens that were known simply as "Cape May Mitts." The women and their daughters knitted warm mittens that became

popular with colonial Philadelphians. It was a far cry from Seventh Avenue or *Project Runway*, but these women did well with their cottage industries. The mitts were apparently their hottest sellers, but they also made socks and caps. They sheared their own sheep, treated the wool at a mill and then designed and knitted the items. After livestock, oysters and lumber, mitt-making was the fourth-largest industry in the county before the Revolutionary War.[14]

Local historian and folk artist J.P. Hand of Goshen in Cape May County meticulously researched and wrote about the mitten industry.[15] He explored the link between the development of Cape May Mitts and Benjamin Franklin. In 1784, Franklin wrote a letter to his friend publisher Benjamin Vaughn, telling him how the captain of a Cape May coastal vessel had aided him and refused to take any money for his services. Franklin and his wife sent the captain's daughter a fancy bonnet as a thank-you for her father's help. When other Cape May women saw the pretty bonnet, they all wanted one, too! The women and girls knitted worsted mittens to sell to Philadelphians so they could obtain caps. As a result, the mittens became a leading export of Cape May County. The incident Franklin had described took place long before he wrote the letter. (Deborah Read was Franklin's common-law wife from 1730 until her death in 1774; thus, the incident occurred sometime during that period.) Franklin died in 1790, and the mitten story was even repeated in some of his obituaries.

Hand located a ledger book from a Cape May County merchant for the years 1761–76 that included 262 accounts, more than 100 of which were women. The ladies of Cape May were making a good income, thanks to the sale of their mittens. Hand has said that Cape May Mitts "may be the first brand name in America."[16] It is hard to believe that this significant piece of women's history was almost forgotten, especially considering its ties to such a great American as Benjamin Franklin. Wives and daughters of the earliest whaling families had been spinning and knitting since they settled at the cape in 1699. But it seems that tales of the male whalers took precedence over those of the industrious women.

A Goshen widow and sheep farmer named Mehitable Simpson is reputed to be the last Cape May County mitten maker. She also knitted socks and caps that were shipped to be sold in Philadelphia. After Mehitable sold her farm in 1871, there seem to be no more references to the mitten industry. In recent years, at Historic Cold Spring Village, a few miles from the city of Cape May, a first-person interpretive program has introduced visitors to Mehitable.

The Cape May mitten trade died out during the Industrial Revolution, when steam-powered machines took over. Although none of the actual mittens have been found to date, it's hoped that some will turn up.

THE GOLD BEATERS

The Hastings Goldbeating Company in West Cape May hired women to pound one-inch strips of gold into extremely thin sheets of gold leaf. These were used for the decoration of various objects. In 1864, George Reeves, who worked for the Hastings Company of Philadelphia, brought goldbeating to West Cape May. Reeves was a descendant of one of the early whaling families of Cape May County. "The Hastings Company were purveyors of precious metals, particularly gold leaf in its usable form."[17] Reeves left Philadelphia and returned to his family homestead in West Cape May, where he built a two-story frame goldbeating shop in the back of his house on York and Broadway.[18] Locals, including women, were hired and trained as goldbeaters. Reeves had about sixty to seventy employees at the height of his business.[19] It is said that the women were particularly skilled goldbeaters.

After Reeves died, his son took over the business. When his son died, it was operated by a woman, Mrs. James Glase, who had been a goldbeater for many years. Eventually, the production of gold leaf was accomplished by using machines, and gold leaf was being imported from Europe. By the late 1940s, the only part of the goldbeating being done at the Jersey Shore location was the "assembling of gold leaf into books."[20] Four or five female employees continued this work in a building about a block from the original factory. In 1961, the goldbeating plant of West Cape May, known for its female artisans, shut down permanently.

Today, a plaque shows the former location of the Hastings Company on Goldbeaten Alley, off Broadway in West Cape May.

DOMESTIC WORKERS

As the New Jersey coast developed in the mid-nineteenth century, rustic boardinghouses were replaced by big hotels and luxurious summer "cottages." These lavish places couldn't operate without employees to do the cooking, cleaning, laundry and stable chores. Many blacks came to New Jersey from the South seeking better jobs and found that most of the work available to them was either on farms or in low-level positions at hotels. By the mid- to late 1800s, a large volume of immigrants came from Europe hoping for a better life and had to take jobs as farm workers, domestics and gardeners. Many of these workers were Italian and Irish,

but many other Europeans came to the area as well. For women, jobs as maids, cooks, laundresses and seamstresses were the best available positions but paid very little.

Harriet Tubman, the famous "conductor" of the Underground Railroad, reportedly worked as a seasonal cook or maid at a Cape May hotel sometime around 1850. She might have also been employed at a private residence. Unfortunately, very little is known about her time at Cape May. In *Hidden History of South Jersey* (The History Press, 2013), author Gordon Bond provides a thought-provoking account of Tubman's life. He writes, "Given the clandestine nature of her mission, finding evidence of her time there is like chasing a ghost. Nevertheless, it is possible to indulge in some reasonable speculation."

Born in Maryland to slave parents around 1822, Harriet had a miserable childhood and suffered a severe head injury after being beaten by a slave master. Tubman's original name was Araminta "Minty" Ross. She became Harriet when she married Tom Tubman, a free black man, around 1844. The marriage lasted only about six years. The deeply religious Harriet was also called "Moses," a name given to her by abolitionist William Lloyd Garrison because she led so many people to freedom. The 1869 biography *Harriet: The Moses of her People* states that Tubman returned to the United States from taking slaves to Canada and "as usual earned money by working in hotels and families as a cook. From Cape May, in the fall of 1852, she went back once more to Maryland, and brought away nine more

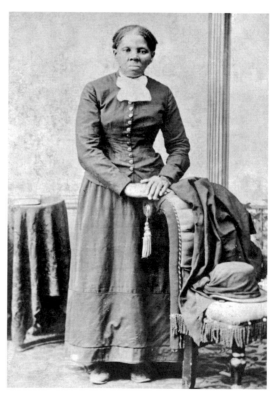

Harriet Tubman, the famous "conductor" of the Underground Railroad, worked at Cape May, circa 1850. *Library of Congress.*

31

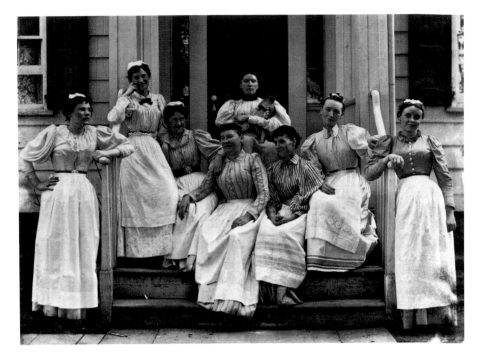

Waitresses, probably European immigrants, taking a break at a Deal inn, circa 1900. The woman sitting in the center is holding a small pet monkey. *Moss Archives.*

fugitives."[21] Harriet herself escaped from slaveholders several times, and she operated as a Union spy during the Civil War. She made about thirteen journeys over a period of around eleven years to rescue slaves, including family and friends. She had to travel at night and followed the North Star. Harriet also helped John Brown to round up men for his raid on Harpers Ferry in 1859. In the years after the war, she crusaded for women's suffrage. Harriet Tubman married again in 1869. In 1913, she died at the age of ninety-one in Auburn, New York, where she had lived in her later years.[22]

The names of most hardworking domestics were not recorded, nor were their personal stories told. Nevertheless, these workers, many of them southern blacks and recent European immigrants, made a difference. Without them, the seashore resorts could not have functioned. Both women and men toiled at these low-paying and sadly unappreciated jobs.

Chapter 2

LIFEGUARDS AND A
CHAMPION SWIMMER

*I am not a militant feminist. I was young and merely wanted to do a job that I
knew I could do well, but never felt that anyone believed me.
—Michelle P., Lavallette, lifeguard in the 1960s–'70s*[23]

W hen "constables of the surf" started working in the mid-nineteenth
century, New Jersey beachgoers could not have imagined women
plunging into the waves to save lives. For one thing, it would have been
awkward for Victorian ladies wearing restrictive bathing costumes to do this.
And besides, it simply wasn't ladylike! Eventually, as women gained more
freedom and their bathing suits became less inhibiting, they were considered
for positions as lifeguards. This recognition didn't happen overnight; it took
many years before women could apply to be professional lifeguards and even
longer before they were acknowledged as equals to their male counterparts.

In the early days, bathers were unguarded, and their usual dip in the surf
was very quick—five minutes or less. Eventually, lifelines (simple ropes tied
to poles that the bathers would hold on to) were used as a safety measure.
Although most bathers were timid, there were always those who would swim
far out beyond the waves or encounter rip currents and run into trouble.
Many drowning deaths occurred along the Jersey coast, and the need for
professional lifeguards became apparent.

Atlantic City's first full-time guards were hired in 1892. The Atlantic City
Beach Patrol was all male for many years. During World War II, consistent
with the shortage of men, Atlantic City hired six beautiful young women to

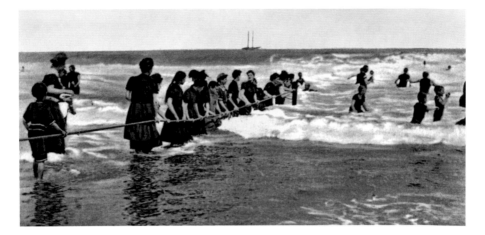

In the late nineteenth and early twentieth centuries, the wool bathing suits became heavy when wet, which led to the practice of "fanny dunking." Women (and some men) would cling to the bathing lines for support while they dunked their posteriors into the water. The lines were often the only safety feature before lifeguards were hired. *Postcard courtesy of Michael "Spike" Fowler.*

be lifeguards. Although it seemed like a great opportunity for the women, it turned out to be a publicity stunt designed to bring business to the resort. Big macho-type men would pretend to be drowning and call for the "girls" to help them. The women soon got tired of this degrading charade and refused to participate in it anymore. There were apparently no female guards hired at Atlantic City until some thirty years later.[24]

At Wildwood, a few able-bodied men were hired as lifeguards in 1905, and more were added over the next two decades. In the 1920s, the guards had the use of makeshift hospital tents pitched right on the sand, but buildings were eventually constructed to house the beach patrol's emergency facilities. A momentous event in 1933 caused heated protests when two women were hired as lifeguards by Wildwood's broad-minded mayor, Doris Bradway. May Ottey and Florence Newton, two capable twenty-four-year-olds from Pennsylvania, had passed the required tests and were highly qualified. Nevertheless, the two women were ridiculed by the newspapers and referred to simply as "the girls." May stuck it out for two summers, and Florence probably worked for only that one season.[25] The hiring of the female guards in 1933 was apparently an isolated event, and most sources suggest that female lifeguards first made a significant presence during World War II. Women took over a variety of jobs as "Rosie the Riveter" types replaced men across the nation.

BELMAR'S TRAILBLAZERS

At the height of World War II, in 1943, a local young woman named Doris Pflug was hired by the Borough of Belmar to work as a lifeguard for the Fifth Avenue Beach. Doris was a regular at the beach when Howard Rowland, director of water safety who would become the legendary captain of the Belmar lifeguards, asked her if she'd like a summer job as a guard. Her answer was a definite "yes!" The attractive twenty-year-old demonstrated what a strong swimmer she was when Rowland tested her, and she passed with flying colors.

A native of Belmar, Doris grew up on Twelfth Avenue, only a half block away from the elementary school she attended. Her father, Harry Pflug, was a contractor who also ran a party boat, which he named the *Doris May* after his daughter. Her parents leased the Sixteenth Avenue fishing pier and operated its food concession. Doris recalls that when she was about seven years old, her mother worked at the luncheonette and kept an eye on her daughter in the surf at the same time. Doris really taught herself to swim, but when she was thirteen, her father hired a swimming teacher for her at the Fifth Avenue Pavilion's pool.

Standing tall at five feet, nine inches, Doris looked terrific in the two-piece bathing suit (not a bikini) she sometimes wore, but she wasn't a trendy 1940s-style pinup girl. She performed her job with skill and dedication. She says that the men she worked with "had respect for her." A few weeks after Doris began, her neighbor and friend Catherine Coveney was also hired as a lifeguard. Doris patrolled the Fifth Avenue beach, and Catherine worked at the Tenth Avenue beach, both extremely popular areas for bathers. Although official records do not exist, they are believed to be the only female guards hired at Belmar in 1943.

Doris explains how she worked from 8:00 a.m. to 6:00 p.m. and was paid twenty-five dollars a week, which was more money in the 1940s than it would be today but still not much. Besides needing the physical strength to rescue people, lifeguards required stamina to carry out their daily grind. Every morning, Doris had to clean up the beach, hauling one-hundred-pound burlap potato sacks around. Doris also remembers having to secure poles out in the water, to which ropes were attached as lifelines for bathers.

When bathers went too far out in the ocean, Doris would help them to get back to shore. You never knew what would happen next. According to Doris, the male lifeguards went on strike one day, demanding better pay. But she and Catherine continued to work and were the only two guards on their

Lifeguard Doris Pflug, one of only two female guards hired at Belmar in 1943. *Courtesy of Doris Pflug Jernee.*

respective beaches! The dispute fizzled out quickly, and the male guards returned to work the next day.

In 1947, Doris married Joseph Jernee, and the couple had two daughters. They lived in Point Pleasant, where Doris worked at Point Pleasant Hospital for fourteen years as an EKG technician. She was honored for saving a man's life by resuscitating him; Doris was always ready to save lives. A woman with many skills, she later owned a uniform shop in Point Pleasant. In 2015, Doris Pflug Jernee, attractive as ever at ninety-two years old, lives in Florida. But she has never forgotten her home, the New Jersey Shore.

Belmar lifeguards, 1945. Jeanne Bonk was the lone female guard during that summer. Legendary head guard Howard Rowland is fifth from right (top row), and Ray Darby (son of Elizabeth Nye Darby—see "Survivor and Salvationist" chapter) is second from right (top row). *Courtesy of Robert V. Pringle; from* Belmar *by Schnitzspahn (Arcadia, 1997).*

As the summer of 1944 approached, Jeanne Bonk was finishing her senior year at Asbury Park High School. A strong swimmer who would be recognized as a star athlete today, she took a summer job as a lifeguard at Belmar. The attractive blonde is said to have passed all the tests that the male guards had to endure. She worked as a Belmar guard again during the summer of 1945.[26]

Bonk was corresponding with a young man named Nicholas Baldino, who was with the Thirteenth Army Air Force in the Pacific. After the war, in November 1946, Bonk and Baldino were married at St. Rose Roman Catholic Church in Belmar. The couple had six children, and Jeanne dedicated her time to raising her family. She taught all her kids and grandkids to swim (one grandson even became a U.S. Navy SEAL). A portrait of Jeanne Bonk Baldino hangs at Belmar's Borough Hall as a tribute to her time as one of the trailblazing lifeguards of the 1940s and will be moved to the new Fifth Avenue Pavilion when it opens. Jeanne died in May 2011, shortly before her eighty-fifth birthday.[27]

After World War II and through the 1950s, there seem to be no records of female lifeguards at the Jersey Shore. But this changed in the 1960s. During the summers of 1961 and 1962, nineteen-year-old Suzanne Kaufer was hired by the Borough of Belmar as a lifeguard. She was a local resident, and her father worked as a Belmar pharmacist. According to Suzanne, she

was Belmar's only female guard during that time. Her assigned area was the L-Street Beach on the Shark River. Suzanne did not guard the ocean beaches, but she didn't mind; it was the way things were at that period in time, when female guards had rarely been seen since World War II. She was happy to have the riverside job. She passed her lifesaving exams with Howard Rowland, the legendary lifeguard captain. She remembers how Rowland would pretend to be drowning to test out his lifeguards' skills. Suzanne says that Rowland was always kind and friendly and took the time to stop and talk with people.

Suzanne felt she was treated with respect by the male lifeguards. Although she wasn't dealing with rough waves at the ocean, she had to meet many challenges. She recalls retrieving a toddler who had drifted off on a raft, and she once rescued a hefty woman who couldn't swim and had fallen out of a rubber tube. The woman seemed to be upset about losing her tube, and Suzanne calmly told her, "We save people, not tubes."[28]

More Lifeguarding Pioneers

Private beach clubs had different policies than the municipal beaches and were more likely to hire women. At Sea Bright in Monmouth County, Bunny Dillon Bell worked as a guard at Elliott's Beach Club in the 1940s. The athletic Bunny graduated from Red Bank High School in 1943 and from Maryland College for Women four years later. She reportedly served as a lifeguard even during early pregnancy with four of her five children. She was the first president of the Junior League of Monmouth County and moved to New York State later in her life.[29]

In Lavallette, one headstrong female resident helped to prove that women were capable of being lifeguards. Carol MacKinnon, though unofficial, was likely the first female guard on the ocean at Lavallette. By 1930, before she was married, Carol received certification as a Red Cross water safety instructor and worked with aquatic programs for disabled people.

In the early 1950s, Carol, who had three young children, lived at the southern end of Lavallette. The beaches at the northern, more developed section of the seashore town had lifeguards, while those close to Carol did not. Although there was a beach a block from her house, she found herself having to trek a half mile with the kids so they could swim at a protected beach. The feisty mom complained to the town officials, but they

wouldn't listen. So she took matters into her own hands. Carol decided to be a volunteer lifeguard for her own family, as well as for the neighboring families. She lugged her old pool and freshwater rescue equipment to the beach and did the best she could. The town officials were embarrassed and made the proper equipment available to the defiant mom.

One of Carol's children, author and former lifeguard Gordon Hesse, didn't know much about his mother's actions when he was a little boy. It was not until many years later, when he was writing a book about lifeguards and their oral tradition, that he found out more about her. He was trying to determine the identity of the first female lifeguard in Lavallette when an older guard from the 1930s he was interviewing asked him if he knew about his mother. The author had not known the details but was surprised to learn that Carol MacKinnon could be considered the first. It was Carol who had always encouraged her son to swim, and he writes, "By her example, I learned respect for the act of mothering and for the ocean."[30]

Patricia "Patty" Lois Fowler and her elder brother Michael, branded as "beach rats," grew up in Avon-by-the-Sea. As kids, they used to hang out at the Washington Avenue beach by the "L" jetty and cove. Taking jobs as lifeguards came naturally for them. Patty, born in 1946, became a lifeguard at Spring Lake in 1967 and, according to Michael, was the first woman hired for a guard position in that town. She was following in the footsteps of her brother, who had starting working as a lifeguard in Avon-by-the-Sea in 1964.

Born in 1946, Patty graduated from Asbury Park High School and Glassboro State Teacher's College (now Rowan University), majoring in kindergarten-primary education. When Patty worked as a Spring Lake lifeguard, she rotated between beach and pool duty during the 1967 and 1968 seasons. She later married, became Patty McCormick and had two children, Michele and Kevin. For many years, Patty taught at Colts Neck Township schools and won an "Outstanding Teacher of the Year" award. Her brother Michael, known as "Spike," retired in 2014 after fifty-one seasons of lifeguarding at the New Jersey Shore. Spike Fowler is coauthor of *Lifeguards of the Jersey Shore*, a comprehensive book about the history of lifesaving along the coast. Lifeguarding seems to run in the family. Carol MacKinnon was Patty and Spike's aunt. Patty's son worked as a lifeguard for several seasons in Belmar, and both of Spike's sons were lifeguards in Avon, Belmar and Bradley Beach. After a brave four-year bout with breast cancer, Patty died in 2007.[31]

The beach patrols' most important work concerned lifesaving, but it was not all about rescues. It was about watching intently and involved

demanding tasks, including practice drills, cleaning up, enforcing beach rules and watching out for runaway beach umbrellas, one of the most potentially dangerous occurrences on the beach.

Women had established themselves as guards along the New Jersey coast during the 1960s and were even more prevalent in the 1970s, but it wasn't until the 1980s that they were truly accepted. In his book *All Summer Long*, author Gordon Hesse shares reminiscences of both male and female guards and explains the Jersey beach culture over seven decades, with an emphasis on the 1960s–'70s. In their own words, the lifeguards tell fascinating tales, both serious and humorous, that expose what lifeguarding was really like. Michelle P.'s story elucidates the challenges faced by a female guard. She worked at Lavallette from 1977 to 1980 and in 1983. At first, she was only supposed to guard the bay, not the ocean beach. The feisty Michelle was an exceptionally strong swimmer who began competing in swim meets at the age of ten. Despite her talent, she felt like she had to prove herself every day to those guards who simply didn't want to be competing with "a girl." But in 1983, her last year of guarding, she said that women were "on the beach to stay."

Today, with equal employment opportunities, female guards are working at most every beach. An All-Woman Lifeguard Tournament, started in 1984, is held each summer at the Gateway National Recreation Area in Sandy

Female lifeguards, Gateway National Recreation Area, Sandy Hook, 2007. *Courtesy of Dave Pearson and Michael "Spike" Fowler.*

Hook. The purpose of the event is to "showcase the high level of fitness and skill women bring to surf-lifeguarding—and thereby encourage others to consider this still-nontraditional line of work for women."[32] The women compete in a variety of exciting contests, including a surfboat challenge, an ocean kayak challenge and Run-Swim-Run, Beach Flags, Ironwoman and Surf Rescue events.

The remarkable female lifeguards along the New Jersey coast perform their various duties with skill and confidence. And if you are drowning, it doesn't matter if your rescuer is male or female as long, as they are capable of saving you!

"A Fish in Water": Gertrude Ederle

"My dad tied a rope around my waist then would lower me down into the water. This was the beginning of my swimming career! In the Shrewsbury River!"[33]

In 1915, a prosperous Manhattan butcher named Henry Ederle rented a bungalow facing the Shrewsbury River in Highlands from William Kruse. Highlands is close to New York, though they seem like worlds apart. Both steamboats and trains transported summer visitors to the area. Henry; his wife, Anna; and their six children enjoyed fishing, boating and swimming at the seaside hamlet of Highlands, where they could enjoy both the ocean at Sandy Hook and the Shrewsbury River. The main industries at Highlands were clamming and fishing. A moderate amount of tourism with a few hotels, restaurants and seasonal rentals helped to boost the economy. During the Prohibition era, Highlands proved to be a hot spot for rumrunning and bootlegging. Even though a number of notorious gangsters lived in the area, summer visitors with families carried on with their daily activities.

Henry and Anna Ederle's daughter Gertrude was born on October 23, 1905, in New York. Little did they know that she would become world famous in 1926, when she became the first woman to swim the English Channel. Perhaps that would never have happened if they didn't vacation at Highlands. It is said that the family called her "Gertie," but she became known to her adoring fans as "Trudy." Highlands was where Trudy learned to swim.

Drownings were frequent, and Henry Ederle wanted to be sure that his daughters could swim. It would be one less thing for him to worry about.

When the portly Henry Ederle escorted Trudy to the Patten Line Pier at Bay Avenue to get her used to the water, her two elder sisters, who had already learned to swim, came along. The skilled butcher trussed a rope, probably a clothesline, around Trudy's waist and dangled her from the pier like a marionette. She floundered in the water until she learned how to swim, and once she did, she became outstanding at it. Later on, it was said she was "like a fish in water." Young Trudy wanted to learn the American crawl, and she savored the challenge of swimming in rough waters. She was strong and healthy but had trouble with her ears. After a bout with measles when she was five, Trudy was left with a hearing problem. Doctors said it would get worse if she kept swimming, but she didn't stop because she loved the sport so much.

After World War I and into the 1920s, styles changed dramatically and reflected the modern attitudes of the flappers. Women donned form-fitting, one-piece swimsuits—so much better for actual swimming! Swimming became the focus of Trudy's life, and she entered competitions throughout her teen years. At the 1924 Paris Olympics, she won a gold medal as part of the four-hundred-meter freestyle relay and took bronze medals in the one-hundred- and four-hundred-meter individual freestyle races. But it was the idea of swimming the English Channel that excited her the most. In the years from 1875 to 1923, only five men had made it across the treacherous body of water. She wanted to meet the challenge of being the first woman to complete the swim, and she made her mind up to do it.

During the course of her training, Trudy swam more than sixteen miles between the Battery and Sandy Hook through difficult currents in what might be called a practice run for her channel swim. After Paris, she focused on the English Channel. Her first try was in 1925 with the backing of the Women's Swimming Association. It didn't work out well. Her coach thought she was drowning when she was only resting. The attempt was aborted, but Trudy wasn't about to give up. On August 6, 1926, at 7:00 a.m., Gertrude Ederle entered the English Channel at Cape Gris-Nez, France. She was slathered with sheep grease! The treacherous body of water lived up to its reputation of being chilly and choppy. Her new coach was Thomas "Bill" Burgess, who had swum the channel successfully in 1911. Trudy's father was there to cheer her on. Her entourage in the accompanying boat played music on a hand-cranked gramophone, including the song "Let Me Call You Sweetheart," a favorite of hers—anything to keep up her morale.

If it had been possible for her to swim a straight line, the distance would have been twenty-one miles, but due to the rough water and changes of

her course, it was around thirty-five miles. It took her fourteen hours and thirty-one minutes to arrive at Kingsdown on the coast of England. Trudy Ederle, the little girl who learned to swim by dangling from a rope at Highlands, had set a record and made world history. A huge ticker-tape parade in downtown Manhattan celebrated her return. An estimated two million people cheered her on, chanting, "Trudy, Trudy!"

Another parade was held on August 31, 1926, at Highlands along Bay Avenue so that the locals could honor Trudy. The spectators went wild! The swimmer brought recognition to Highlands. In an oral history project conducted in 2000, Mae Schwind Bahrs, a longtime Highlands resident and real estate agent, spoke about Trudy Ederle and how she learned to swim at Highlands. Bahrs said, "She brought international celebrity status to the town."[34]

America was in love with Trudy. She met President Calvin Coolidge, who called her "America's best girl." The great impresario Irving

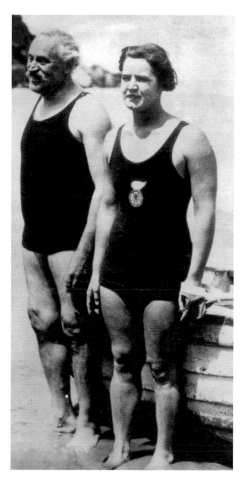

Gertrude Ederle, the first woman to swim across the English Channel, learned to swim in Highlands, New Jersey. She is pictured here with her trainer, Bill Burgess, in France, 1926. *Author's collection.*

Berlin published a song in her honor. During the Roaring Twenties, Trudy was so popular that the press followed her everywhere and couldn't get enough of her. "Modest and unassuming, she was the antithesis to the flappers of the day, a clean living young woman whose smiling face became a fixture of the tabloids and broadsheets that engaged in fierce daily battles for circulation in New York City."[35] She was wholesome and tomboyish. Her figure was fuller than the lithe flapper girls. Average people could relate to her, although, of course, they didn't have her talent for swimming.

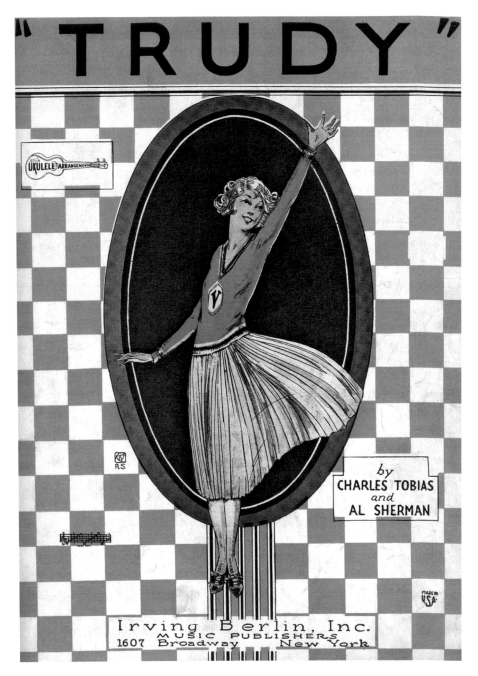

Sheet music cover for "Trudy," a song published by Irving Berlin in 1926 to celebrate Gertrude Ederle's success as the first woman to swim across the English Channel. *Author's collection.*

To capitalize on the Trudy craze, Paramount Pictures made a silent feature film titled *Swim Girl, Swim*. Released in 1927, the film stars BeBe Daniels and features Trudy, who plays herself in a small supporting role. *Swim Girl, Swim* played at the Marine Theater in Highlands, which was open only in the summer. The house was continually packed with locals who wanted to see their famous Trudy. (The theater building still stands and was remodeled to become the Lusty Lobster, a seafood business).

Adoring men sent Trudy love letters and proposals of marriage. She was almost married in 1929, but after her suitor took off, she apparently didn't want to be hurt again. So, she never married and had no children. Trudy worked in vaudeville for a short time but gradually withdrew from the limelight. Her deafness increased, and she suffered from nervousness and stress. In 1933, she fell on a staircase and fractured her vertebrae, an injury that caused her pain for the rest of her life. She cut back on public appearances, although she did appear in Billy Rose's Aquacade at the 1939 New York World's Fair. During World War II, she worked at LaGuardia airport testing flight instruments. She taught swimming to children at the Lexington School for the Deaf in New York, a job she enjoyed, as she related well to her pupils. For the remainder of her life, she lived quietly in Flushing, Queens, with two female friends. Over the years, Trudy sometimes visited Highlands during the summer and stayed at a hotel.

Near the bridge in Highlands, on a gentle slope across from Bahrs Landing, Ernest "Sonny" Vaughn turned a vacant lot into a park. A group of local gardeners called the Green Thumbers helped with the planting. The little park was dedicated to Gertrude Ederle on August 14, 1975. The Highlands Garden Club worked on the site, expanded the flowerbeds and added a lovely flower urn. The club held a rededication ceremony on August 21, 2003, that was attended by Trudy Ederle herself. She was ninety-seven years old at that time.[36]

Later that year, on November 30, 2003, Gertrude Ederle died peacefully at a nursing home in Wyckoff, New Jersey, at the age of ninety-eight. She was survived by ten nephews and nieces. The remarkable athlete never forgot Highlands, the place where she first learned to swim. And the people of Highlands will always remember their beloved Trudy.

The opening lines to the last verse of Irving Berlin's "Trudy" goes like this: "Trudy, we love our swimming daughter/Trudy, you're like a fish in water."

Chapter 3

First Ladies on Vacation

What a boon our cottage at Long Branch was to the President! Tired and weary as he was with his monotonous official duties, he hastened with delight, as soon as Congress adjourned, to its health-giving breezes and its wide and restful piazzas.
—Julia Dent Grant, The Personal Memoirs of Julia Dent Grant

Everyone needs an escape, but for public figures, it has always been difficult to find a private place. You can count on the news media to reveal the "secluded" locations where famous families spend their vacations. Examples of well-known presidential retreats are Teddy Roosevelt's Sagamore Hill at Oyster Bay, Long Island; the Kennedy Compound at Hyannis Port, Massachusetts; and George H.W. Bush's home at Kennebunkport, Maine. Both summer and winter "White Houses" are recognized throughout the history of the American presidency.

The New Jersey Shore provided an ideal destination for a number of first families from the mid-nineteenth through the early twentieth centuries. The journey from Washington, D.C., was a relatively easy one by boat, train or, eventually, automobile. Much of the Jersey coast was rustic but yet not far from the cities. The sea air and salt water were invigorating, and the mosquito population was far less threatening than in the nation's capital.

Cape May, "America's first resort," at the southern tip of New Jersey, hosted five U.S. presidents at Congress Hall. The handsome oceanfront hotel, still in business today, was the choice of both northern and southern leaders during the antebellum period. Congress Hall, with its L-shaped

veranda and stately white columns, looks much the same today as it did in the nineteenth century. The historic hotel exudes Victorian charm, but of course, modern conveniences have been added. The five chief executives who stayed at Congress Hall were Franklin Pierce, James Buchanan, Ulysses S. Grant, Chester A. Arthur and Benjamin Harrison.

Long Branch in Monmouth County, the resort that "entertained a nation," developed somewhat later but soon caught up in popularity to Cape May. Seven presidents summered at Long Branch. "The Branch" especially appealed to well-heeled visitors because of its gambling clubs, horse racing and lively parties.

"Can you name the seven presidents who stayed at Long Branch?" is a frequently asked trivia question at the New Jersey Shore resort. The answer: Ulysses S. Grant, Rutherford B. Hayes, James A. Garfield, Chester A. Arthur, Benjamin Harrison, William McKinley and Woodrow Wilson (West Long Branch). Only a few sites associated with the presidents survive at Long Branch today.

Did the chief executives bring their wives along? Of course! The ladies wouldn't miss it. For most of them, it was a family vacation. One of them visited without the president, and another was recuperating from illness while her husband was in Washington. What could be more healthful than spending time by the sea, away from the sweltering heat and unsanitary conditions in the nation's capital? The following vignettes describe some of the first ladies who sojourned at the New Jersey Shore.

A DOMESTIC DIVA: CAROLINE HARRISON

The petite Caroline Lavinia Scott Harrison represents one of the most talented but least recognized of all the first ladies. In her later years, she became embroiled in a shocking scandal involving her summer home at Cape May.

Born in 1832 in Oxford, Ohio, Caroline Scott, called Carrie, was the daughter of a math and science professor (and also a minister) at the newly opened Miami University in her hometown. Carrie and her siblings received a fine education, and she possessed an exceptional flair for housekeeping. In her book *The First Ladies*, author Feather Schwartz Foster calls her chapter about Carrie "Alias Martha Stewart" and explains, "At a time when being a good housekeeper was considered the highest compliment a woman could receive, Caroline Harrison excelled in household management."

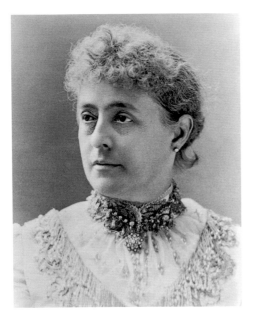

First Lady Caroline Harrison, wife of President Benjamin Harrison, who was in office from 1889 to 1892. *Library of Congress.*

Carrie met her husband at Miami University and married him in 1853, when she was twenty-one. Benjamin Harrison was the grandson of a president but didn't want to rely on the family name. He struggled as a young lawyer and had few clients, perhaps due to his rather cold and dull personality. He and Carrie moved to Indiana, but she returned to Ohio for the birth of their first child, a son, in 1854. Four years later, she gave birth to a daughter (a second daughter was stillborn in 1861). The couple's marriage was strained until the Civil War, when Benjamin allegedly realized the value of family life. After the war, his law firm began to thrive, and he became a good prospect for a political office. As the Republican presidential candidate in November 1888, Harrison defeated incumbent Grover Cleveland, a native of New Jersey, not by popular vote but by electoral vote. (Four years later, Cleveland would defeat Harrison and become president for a second time.)

At the White House, the industrious Carrie spruced things up and made sure the staff functioned efficiently. She had conveniences added to the aging building by installing that new marvel, electricity. Perhaps her best-known domestic contribution was to introduce the first indoor Christmas tree at the White House. A skilled artist, the first lady did watercolors and painted flowers as well as other motifs on fine china. Her exquisite designs graced White House dinnerware and decorative pieces. Carrie is often credited with making china painting a popular art form in the late Victorian era and established the White House collection of china.

Although she seemed to have boundless energy, Carrie suffered from respiratory problems throughout her life. In photographs, dark circles are noticeable beneath her eyes. She relished the idea of escaping the stagnant Washington, D.C. air and unbearable humidity by going to the seashore.

Carrie fell in love with Cape May Point after the first family visited the Wanamaker's summer home there in 1889 just a few months after Harrison took the oath of office. John Wanamaker, the famous Philadelphia department store mogul, had been appointed postmaster general by President Harrison. Wanamaker and some of his well-to-do Republican buddies conceived a clever scheme to make Cape May Point the first family's summer home. The area, previously known as Sea Grove Presbyterian Retreat, was struggling to pay county taxes, and the investors feared bankruptcy. They needed to do something that would attract more people—if the president had a home there, people would follow! So, with the first family in mind, they had a handsome "cottage" with twenty rooms and big porches constructed. When the Cape May Point cottage was ready, Wanamaker knew the president could not accept the gift, so he went to the White House and personally presented the deed and keys to the first lady.

When the public learned that the Cape May Point house was a "gift" to Mrs. Harrison, there was widespread disapproval. The president's enemies turned it into a political scandal. Carrie was appalled that she would be accused of taking a bribe and insisted that none of the men who were involved in giving her the home were seeking political offices or favors. She insisted that the president was not receiving any monetary benefit from the Cape May Point cottage. Harrison claimed that he didn't know about it when Wanamaker gave Carrie the deed. He was supposedly in a different room of the White House, and when he found out, he said he would pay for the cottage. He later wrote a $10,000 check to Wanamaker to pay for the house.[37]

Harrison established offices at Congress Hall in Cape May as his official "Summer White House" instead of the Cape May Point cottage. Despite all the controversy, the first family enjoyed good times at Cape May Point. Carrie pursued her artwork and painted seascapes and flowers in the lovely gardens. Similar to the efficient way she ran the White House, she managed the summer home with care. She loved having her grandchildren visit the seashore house and indicated in her diary that she felt it was good for them. Carrie even selected the groceries personally and sent orders to Hand's Central Market at Washington and Ocean Streets.[38]

Besides her involvement with artistic and domestic pursuits, Carrie advocated women's rights and became the first president of the Daughters of the American Revolution (DAR). In 1892, the first lady developed tuberculosis and spent a summer in the Adirondacks to restore her health. After failing to improve, she returned to Washington, D.C., and died on October 25, 1892, at the White House while her husband was still in office.

In 1896, Benjamin Harrison married Mary Lord Dimmick, a young widow who was his secretary and a niece of his late wife. During that year, Harrison also sold the Cape May Point cottage back to Wanamaker for $10,000.[39] The cottage, originally at Beach and Harvard Streets, still exists but has been moved inland to Cape and Yale Streets and is now a Marianist retreat house.

THE BELLE OF THE BRANCH: MARY TODD LINCOLN

She didn't frequent Long Branch or ever own a summer cottage there, but her visit in August 1861 was a well-publicized event that greatly boosted the resort's fame. While President Abraham Lincoln was busy with the start of the Civil War, only a few months earlier, Mrs. Lincoln had packed her finery and taken their sons, Willie and Tad, to enjoy a vacation at Long Branch. Mary and the boys stayed at Samuel Laird's Mansion House, a prominent oceanfront hotel. (Today, a plaque at Pier Village presented by the Long Branch Historical Association commemorates Mrs. Lincoln's visit and the site of the former hotel.)

Soon after the first lady's arrival, local officials showed off the latest techniques of rescue work, including a demonstration of former New Jersey governor William A. Newell's apparatus for firing a lifeline from shore to ship. Visitors and locals alike flocked to the event, mainly to get a look at the much gossiped-about Mrs. Lincoln.

The first lady created quite a sensation, and an evening soiree was given in her honor at the Mansion House. All eyes were on Mary Lincoln as she entered the ballroom accompanied by ex-governor Newell. She had a reputation for spending money on clothes, and the *New York Herald* noted that "Mrs. Lincoln was dressed in an elegant robe of white grenadine, with a long flowing train, the bottom of the skirt puffed with quillings of white satin, and the arms and shoulders uncovered save with an elegant pointlace shawl. She wore a necklace and bracelets of superb pearls, a pearl fan, and a headdress of wreathed white wild roses. Beyond all comparison, she was the most richly and completely dressed lady present."[40] Her jewelry was likely a pearl set that her husband had given her as a gift at the time of his inauguration. If so, they probably weren't the finest pearls, as the president apparently wasn't the best gem shopper, but they were nonetheless attractive.

Despite all the fanfare and the attention bestowed on the first lady, Mary Lincoln was not well liked by the public. She came from a well-heeled Kentucky family, and many Northerners felt that she was pro-Confederacy or maybe even a spy for the Rebels. (Despite those rumors, she wasn't.) Mary figured that with her good taste, she'd be well received and admired as a gracious White House hostess. She was instrumental in helping her lanky husband to dress sharper, be aware of his posture and even to dance.

Mrs. Lincoln's holiday at Long Branch lasted about ten days. By the time she returned to Washington, "Long Branch troops, who had volunteered in response to the President's call in April, were seeing active service in covering the retreat from Bull Run."[41] Volunteers from Monmouth County were actively guarding railroad tracks and telegraph wires between Washington and Annapolis, and later they were involved in such major battles as Fredericksburg and Chancellorsville.[42]

First Lady Mary Todd Lincoln, wife of President Abraham Lincoln, wearing one of her fashionable ball gowns, circa early 1860s. *Library of Congress.*

The first lady's already precarious mental health deteriorated after the death of the couple's son Willie at age twelve. On April 14, 1865, Mary witnessed the horrifying point-blank killing of her husband by John Wilkes Booth at Ford's Theater. And on top of all her hardships, in 1871, her youngest and adored son, Tad, died at age eighteen. Her eldest child, Robert, was the only one of the Lincoln sons who survived. The trauma she suffered was overwhelming. When Mary died in 1882, she was a lonely and destitute woman.

THE GENERAL'S WIFE: JULIA DENT GRANT

In June 1865, just two months after the Civil War ended, General and Mrs. Ulysses S. Grant paid a visit to Cape May. The triumphant Union general reviewed a group of reserves in full regalia as they presented a military drill. A large crowd watched the event, which took place on the lawn of Congress Hall, where the Grants were staying. Affluent businessmen who had recently opened a yacht club at Cape May tried to persuade the general to choose the resort as his summer home. However, Grant was more interested in the gaudier resort of Long Branch, most likely because he loved fast horses and could drive them there.

Julia Dent was born in 1826 in Missouri to a slaveholding farm couple. Though not the prettiest first lady, she was outgoing, confident and well liked. She had a "cross-eyed" condition that caused her to usually turn her head to the side rather than showing her full face in photographs. Captain Grant was a classmate of her brother at West Point, and she carried on a romantic correspondence with him. Julia and Ulysses married in 1848 and had four healthy children. They struggled without much money for a few years, but things would improve dramatically after the Civil War, when General Grant became a national hero. Grateful people from all over the country showered the couple with extravagant gifts.

Soon after Grant became president in 1869, a group of his wealthy friends purchased a cottage for the first family on Ocean Avenue, in the Elberon section of the city. The home was deeded to Julia because it wouldn't "look right" for President Grant to accept such a gift, and yet he seemed to accept every other gift that came his way. One of these men, George W. Childs, publisher of a Philadelphia paper, was instrumental in encouraging Grant to come to Long Branch. Childs, a man with good business acumen, owned property in the city and knew the president's summer home would lure even more visitors to Long Branch, which was already attracting theatrical stars and famous tycoons. The first family's Elberon cottage on Ocean Avenue soon became the "Summer White House."

After the Monmouth Racetrack opened in 1870, U.S. Grant was often spotted at the races. Together, the Grants enjoyed drives on the beach with their two younger children, Nellie and Jessie, who were often in the limelight. The family frolicked in the surf, and Julia enjoyed entertaining guests at their cottage, including the kids' friends and Julia's aging father, Colonel Dent. Life was so hectic in Washington, D.C., that they didn't get to see much of their children, but at Long Branch, they could spend quality time with them.

The Ulysses S. Grant family at their Elberon (Long Branch) cottage in the early 1870s. Ulysses is seated with First Lady Julia standing behind him. *Author's collection.*

After Grant's two terms in office were over, the family traveled the world for two years. On their return, Grant was involved in a Wall Street scam, but his marriage and family life were happy. The Grants summered at Elberon throughout his eight years as president and for a while beyond that. As Julia described in her memoirs, it was at the Long Branch cottage that "the fatal malady first made its appearance in General Grant's throat." He was eating a peach when he felt a burning pain. In the summer of 1885, the Grant family moved to Mount McGregor in upstate New York. Despite his struggle with throat cancer, Grant finished writing his memoirs, the sale of which gave financial security to his family, not long before he died on July 23, 1885.

After "the General's" passing, Julia wrote wonderful accounts of their life in her memoirs. Sometime after Julia died in 1902, her writings were discovered in a granddaughter's attic and finally published in 1975. Julia recalled a grand ball given in the Grants' honor at the West End Hotel soon after their arrival at Long Branch. The newspapers described the "beautiful toilets of the different ladies," and one journalist said that the first lady's

toilet "reminded him of a spray of dogwood in May." Julia was thrilled with this comment.

The former first lady reminisced in her memoir about some amusing moments that she and her husband shared. One time, the president came into her room at their Long Branch cottage to tell her that he had a new conundrum for her. She was all ears. He asked her, "Why is victory like a kiss?" She repeated, "Why is victory like a kiss?" and then gave up, anxious to hear his answer. "Why," the general exclaimed, "it is easy to GRANT." This might sound corny today, but if the Victorians had social media, it would likely have been posted and followed by "LOL."

THE VALIANT CRETE: LUCRETIA GARFIELD

Her time as first lady was cut short by the horrific shooting of her husband, President James A. Garfield, in 1881. The crazed assassin would change her life forever. The first lady's sojourn at Elberon (Long Branch) during that fateful summer fits prominently into the accounts of her husband's desperate fight for his life. Mrs. Garfield would stand by her man until he died at the resort they loved so much.

Although Lucretia Garfield was the nation's first lady for only about six months, she is remembered for her intellect and her courage. Born in Garretsville, Ohio, in 1832, Lucretia Rudolph's ancestors are said to have come over on the *Mayflower*, and her background has been the subject of extensive research. She studied French and classical literature and worked as a teacher. She supported the ideals of women's rights (although she didn't approve of public demonstrations) and took an interest in the needs of the blind. We can only speculate as to all "Crete" might have accomplished as first lady. She lived to be eighty-five years old and continued to lead a full and active life until her death in 1918.

The demure Lucretia Rudolph and the outgoing professor James Garfield, who had worked his way up from an impoverished childhood, carried on an extended correspondence. They were married in 1856, and their correspondence continued into the early years of their marriage, as he was often away. Garfield had an affair with a woman in New York, which he later revealed to his wife and deeply regretted. The couple struggled to make their marriage work, but his absence while serving in the Union army and then as a congressman added stress to their shaky relationship. In 1863, after

the death of their first child when she was only three years old, the Garfields became closer. They would have six more children; five of them survived and lived long lives, but their last child died when he was a toddler. Garfield ran on a Republican ticket and was elected president in 1880.

Like so many others during their era, the Garfields felt that sea air and salt water had curative powers. Washington, D.C., was experiencing a severe outbreak of malaria, and in early May 1881, Lucretia contracted it at the White House. The first lady almost died but improved enough to travel. The devastated president had too much work for an extended leave, but the first lady went to stay at the Elberon Hotel at Long Branch in early June.

A few days before Crete was stricken with the disease, she had greeted a guest named Charles Guiteau at a reception. Guiteau later described the first lady as "chatty and comfortable." Guiteau was a follower of the Stalwarts, a division of the Republican Party that opposed Garfield, and is usually described as a "disappointed office seeker." The madman stalked the president, determined to find an opportune time to shoot him at close range. When Garfield arrived at the railroad station with Lucretia to see her off as she left for Long Branch, Guiteau was there, intending to pull the trigger. However, he withdrew because the first lady seemed so ill and fragile that he could not bring himself to kill her husband right in front of her. It has been mistakenly reported over the years that Guiteau was stalking Garfield at Long Branch and almost shot him at a church; however, this attempt took place at a Washington, D.C. church, not in Long Branch.[43]

On July 2, at the Washington, D.C. railroad station and while the first lady was at Elberon, Guiteau fired two shots at Garfield. One bullet grazed the president's arm, and the other entered his back. President Garfield was alive but gravely wounded. The shooter was quickly sent to jail and the stricken president taken to the White House. Though terribly weak, Crete rallied and rushed back to Washington from Elberon to be with her husband. He was attended by several doctors, went through surgeries and lingered on during the rest of the summer. Showing great stamina for a woman who had been so ill, Crete looked after him. Newspaper reports depicted her cooking for him, but this is doubtful. Though it seemed improbable, Crete persuaded the doctors that her husband should be transported to Long Branch. He'd be away from the unbearable heat and bad vapors of the Potomac flats. On September 6, Garfield was taken by train to Elberon. He was accompanied by Crete, who would be able to care for him in a healthier environment.

Dozens of seaside cottage owners offered their homes to the president for his recuperation, but the one chosen belonged to Charles Francklyn.

Lucretia "Crete" Garfield comforts her wounded husband, President James A. Garfield, at the Francklyn Cottage in Elberon (Long Branch). His bed was positioned so he could view the sea. Garfield died here on September 19, 1881. *From* Pictorial History of President Garfield's Career *(New York, 1881)*.

It was located on the grounds of the Elberon Hotel, a place the Garfields had frequented. The president was moved from Washington, D.C., to Long Branch on a comfortable train. Citizens of Long Branch rallied and joined forces to construct a railroad spur, almost a mile long, to deliver the wounded president from the Long Branch station right up to the door of the Francklyn Cottage. Local workers toiled throughout an extremely hot day and night

to complete the tracks.[44] The amazing feat accomplished, Garfield arrived safely at the cottage. He was glad to be by the sea.

At first, he showed signs of improvement; however, his condition soon worsened, and he died at the cottage on September 19 with Crete and their teenage daughter Mollie by his bedside. Numerous articles and studies in recent times suggest that Garfield would have lived if only such wondrous drugs available today had existed and his treatments had taken a different direction. Although his doctors at the time thought they were doing what was best, it seems their prodding and poking to find the bullet lodged inside the president likely contributed to his death.

Lucretia Garfield never returned to Long Branch. Perhaps the memories of her husband's agonizing passing would haunt her if she did. She chose to live in Pasadena, California, and other locations in her later years. She was well respected and was able to live out her long life as a wealthy widow due to the funds allocated to her by the federal government and private citizens. She resumed her intellectual pursuits, made sure that her children received a good education, devoted time to memorializing her husband and established the first presidential library. Although she had only a brief stint as first lady, Lucretia "Crete" Garfield was truly a remarkable woman.

MORE FIRST LADIES AT LONG BRANCH

Lucy Webb Hayes, the wife of Rutherford B. Hayes, president from 1877 to 1881, is best known for her moniker "Lemonade Lucy." A deeply religious woman, she believed in the temperance movement and suspended the use of alcohol at the White House. President and Mrs. Hayes vacationed at Long Branch, spending enough time at the Elberon Hotel that the city retained its reputation as the summer capital. But they never had their own cottage and were said to prefer staying at the hotel, which was comfortable and "modern."

Chester A. Arthur was a widower known as "Elegant Arthur" when he became president after the death of Garfield. He did not remarry, remaining a bachelor for his term in office, although he did visit Long Branch and stay at the Elberon Hotel. Arthur also visited Congress Hall at Cape May in 1883 with his daughter Nellie.

There's only scanty information about President McKinley and his wife, Ida, visiting Long Branch. But McKinley's first vice president, Garrett

Hobart, was born in West Long Branch and frequented the area. Any trips the McKinleys made to the shore area were likely to visit with the Hobarts.

Edith Galt Wilson, the second wife of President Woodrow Wilson, visited Shadow Lawn in West Long Branch with her husband, but very little is known about her activities there. Shadow Lawn was the 1916 Summer White House where Wilson made his acceptance speech for his second term of office. At the mansion, on the night of the election, Wilson and Edith had gone to bed thinking he had lost but woke up to find he had won! In 1917, a group of locals made an attempt to purchase Shadow Lawn as the official Summer White House, hoping it would bring continued business to the area. They were unsuccessful, and that marked the end of Long Branch's time as the "summer capital." The mansion burned down in 1927 and was replaced by another one that is now Wilson Hall, a part of Monmouth University.

Chapter 4

REFORMERS AND CRUSADERS

"MOTHER DOWNS": SARAH CORSON DOWNS

"This foe stands upon the threshold of every home in New Jersey and is the inspiration of every crime which disgraces our civilization…The law of this state is license, and license means drunkenness, pauperism and crime."[45]

When Sarah Corson Downs gave a speech, her audience straightened up and listened. Although a rather large and daunting woman, she was motherly and sweet. The nineteenth-century temperance leader was an Evangelical Methodist who spent most of her life at the New Jersey Shore. As an Ocean Grove resident in her later years, she became an important figure in the Woman's Christian Temperance Union (WCTU).

Born in 1822, Sarah Jane Corson came from a Philadelphia family with roots imbedded in American history. Her mother, Ann Addis Corson, was the daughter of a Revolutionary War veteran, and her father's ancestors were some of New Jersey's earliest Dutch settlers. Sarah was the youngest of four children, with two brothers and a sister. The family belonged to the Dutch Reformed Church. When Sarah was only five years old, her father died. Her widowed mother decided to take the children and move to Pennington, New Jersey, and live with her sister.

At the age of seventeen, Sarah experienced a "conversion" and encouraged her mother and other family members to be baptized as Evangelical Methodists. The doctrines of Methodism would become the

dominant force that motivated Sarah throughout her life. She taught school in Pennington for a little while and then in New Egypt for seven years.

In 1850, Sarah left her teaching job to marry Reverend Charles S. Downs, a Methodist circuit minister who traveled to various congregations in southern New Jersey. Sarah helped him with church functions and taught Sunday school. The couple had four children together; two died as toddlers, but a boy and a girl survived. Reverend Downs also had two sons from a previous marriage. Sarah raised her two surviving children as well

A photo of the formidable "Mother Downs" from the frontispiece of *The Life of Mrs. S.J.C. Downs*, a memorial book by Reverend J.B. Graw published in 1892, the year after her death.

as the reverend's boys. In her work as a temperance leader, she was fondly known to all as "Mother Downs."

When Reverend Downs's health began to fail in 1860, he retired from the ministry and moved his family to Tuckerton on the Jersey coast, where he had spent his childhood. Sarah operated a small private school in her house and then in a rented hall while she also taught part time in the public school. She wrote a local news column for the *New Jersey Courier*, which was published at Toms River. Reverend Downs was an invalid who needed care, and the fourteen years Sarah lived in Tuckerton were said to be the "saddest and most trying years of her life."[46] After her husband died in 1870, she established a Ladies Aid Society. Her main activity was raising money to finance the construction of a new Methodist Episcopal church in Tuckerton. Mrs. Downs planned all sorts of fairs, festivals and exhibits to help pay for the new church. Sarah Downs was well liked and always had a good word for everyone. She even hummed inspirational hymns as she worked.

Sarah moved to Ocean Grove in 1874. She spent most of her time working for the WCTU and soon became a more influential leader in the

organization. Her formidable ability as an effective speaker helped her rise to power. Downs was an enthusiastic supporter of Frances Willard, a Methodist female suffragist who was president of the national WCTU from 1879 until her death in 1898.

In Ocean Grove, Sarah lived in a cottage at 104 Mount Tabor Way (a site that is listed on both the Ocean Grove Women's Heritage Trail and the New Jersey Women's Heritage Trail). WCTU meetings were held at the Hygeia Hotel and at the White Ribbon Cottages (the white ribbon was a symbol of purity).

Downs became president of the New Jersey WCTU in 1881 after a state convention selected her. She worked hard, and the membership increased under her leadership. She fought for abstinence in a state with a growing population of immigrants who were "wets" in favor of legal alcohol. Some of the temperance ladies objected to Willards' support of suffrage as a means to achieve prohibition. Downs's main interests were "prohibition and home protection" with "gospel temperance." Her support of suffrage came only after the strong arguments of other New Jersey union women. She favored it as a means for women to better protect their homes and children.[47]

In her 1885 annual address to the WCTU, Downs expressed the following thoughts:

> *Prayers are heard but ballots count. Both are hemispheres of the same golden globe: separate them, and they are useless; unite them, and they are an irresistible force. God had a purpose in keeping women so long in the background of the temperance reform; now as a reserve power, they are brought to stand side by side with men…toward the final overthrow of the greatest enemy of the home and of our common humanity.*[48]

Of course, the enemy she referred to was alcohol, known as the "demon rum." On occasion, Mother Downs stated what she believed in simpler terms, but she always inspired her audience: "Punish the drunkard—yes! Punish the rumseller—yes!"[49]

In 1889, on the occasion of Sarah's sixty-seventh birthday, during a stay at the Hygeia Hotel, the Ocean Grove Union wanted to honor her with a surprise birthday reception. Sarah arrived home, weary after a journey, and was greeted by her friends. During the evening, one of the "ministerial brethren" presented her with a new dress for her birthday (probably a needed luxury for the plain and frugal Downs) and said:

My dear Mrs. Downs,
I hope that the gowns
That envelope your years, sixty-seven
May each be succeeded
As long as they're needed,
And then the white robes of heaven.

On November 10, 1891, Sarah Corson Downs died from a flu-like illness at her daughter's home in East Orange. She was said to have kept up with WCTU affairs from her sick bed even on the day of her death. Temperance leaders from around the world sent condolences.

The year after her death, a memorial book was published. *The Life of Mrs. S.J.C. Downs; or, Ten Years at the Head of the Women's Christian Temperance Union of New Jersey*, edited by Reverend J.B. Graw, includes excerpts from her powerful speeches, as well as tributes written about her.

Sarah Corson Downs is remembered for her stirring speeches and her devotion to her family, her religion and the temperance movement.

OCEAN GROVE: A WOMAN'S KIND OF TOWN

It's no wonder that Sarah Corson Downs moved to the pious seaside resort of Ocean Grove, which has been called "a haven" for broad-minded women. Those who lived in the Methodist camp meeting town, founded in 1869, enjoyed equal opportunity not present in most New Jersey communities during the late nineteenth century. "By 1900, 63% of the town's population was female, the largest proportion being single and widowed women."[50]

Ocean Grove was founded on the Holiness Movement, which evolved from the Methodist Movement and promoted a pure and healthy life. One of the few religious campaigns in which women could speak publicly, the Holiness Movement attained a widespread, international following. Today, Ocean Grove (Neptune Township) is well known for its gingerbread houses, stores and restaurants, and the town is still under the auspices of the Methodist Camp Meeting Association. The Great Auditorium, where sermons and concerts have been held since the 1890s, and the surrounding residential tents convey an aura of summers in the Victorian era.

Dozens of influential women have spoken at the Great Auditorium over the years, including Sarah Corson Downs, Frances Elizabeth Caroline

Gayle Eggen Aanensen, author of *Summer of the Suffragists*, playing the role of temperance leader Sara Corson Downs during a tour of the Ocean Grove Women's Heritage Trail in 2014. Aanensen is holding an authentic "temperance pledge." *Photo by author.*

Willard, Carrie Lane Chapman Catt, Mrs. Jesse Grant (mother of U.S. Grant), Mrs. James A. Garfield and African American evangelist Amanda Berry Smith. Other famous women who've made appearances are Helen Keller, Dale Evans, Marion Anderson, Pearl Bailey, Emma Eames and the list goes on.[51]

Historian and Ocean Grove resident Lyndell O'Hara has conducted extensive research and continues to explore the fascinating stories of women who lived in her town. A history professor at the Manhattan campus of Nyack College, O'Hara has been leading walking tours around Ocean Grove for the past few years. Her focus is on women's history of the town from the

1870s to 1900. The popular summer tours, run by the Historical Society of Ocean Grove, begin and end at the society's museum on Pitman Avenue, where tickets are sold. With knowledge and enthusiasm, "Dell" describes the lives of various women as she takes groups of attentive tourists, locals, writers and history buffs around town. Several costumed interpreters add a fun and exciting component to the walking tours. On a delightful morning tour attended by this author on August 14, 2014, Sarah Corson Downs; the Bull sisters, who ran the Aurora hotel; and the commanding female preacher Phoebe Palmer gave presentations and answered questions in character.

Many Ocean Grove women functioned as successful entrepreneurs. Most of the boardinghouses, hotels and other tourist enterprises were run by women who leased property from the Camp Meeting Association. From about 1880 to 1910, there were ten physicians in Ocean Grove, five of whom were women. Dr. Margaret Coleman operated a small hospital at the Block House and even used such innovations as electrotherapy as a cure. (This building is now the Allenhurst on Pitman Avenue, where the tour stops at a shady spot outside to hear Dell speak about its past). But just being by the sea was considered to be a remedy for all sorts of ailments. Ocean Grove, known by the Camp Meeting Association's slogan "God's Square Mile at the Jersey Shore," represents a small town with a big history of remarkable women.

You can learn more about the women's history sites of Ocean Grove at www.oceangrovehistory.org/WomansTrail.html.

Survivor and Salvationist: Elizabeth Nye Darby

"The sky was alight with stars, but the sea looked like black ink. I don't remember being afraid, but I thought what a horrible way to die in that black, icy water."[52]

Among the relics scattered near the ghostly remains of the RMS *Titanic*, scientists found a small, white porcelain watering can during a 1987 expedition. After lying on the ocean floor for seventy-five years, the delicate souvenir decorated with painted flowers had survived in pristine condition, except that its handle was missing. The words on the jug in gilt script, "A Present from Folkestone," were as clear as the day it was made.

Mrs. Elizabeth Nye was the only passenger on the *Titanic* who came from Folkestone, a seaside resort town on the English Channel. There is little doubt that the item belonged to her. Elizabeth, a second-class

The "unsinkable" RMS *Titanic* departing Southhampton on April 10, 1912. Elizabeth Nye Darby, who lived in Belmar and Asbury Park during her later years, was one of the survivors. *Wikipedia Commons.*

passenger, was one of the 705 survivors of the disaster. More than 1,500 souls perished on April 15, 1912, after the "unsinkable" White Star luxury liner hit an iceberg and sank in the North Atlantic. The twenty-nine-year-old British widow was returning to Orange, New Jersey, where she had been living after the death of her first husband. She would later become a resident of the New Jersey Shore.

When passengers scrambled into lifeboats on that fateful night, they didn't give much thought to the items they left behind. Their luggage and personal effects remained in their cabins, many of the items eventually recovered on the ocean floor. Controversies arose as to whether the site of the wreck should be left alone and respected as a burial ground or if the artifacts should be recovered and preserved for posterity. Items such as leather shoes, dishes and jewelry were retrieved and are now macabre reminders of the historic tragedy.

Elizabeth was on born May 27, 1882, in Folkestone, Kent, to Thomas and Elizabeth Ramell, a hardworking, pious couple. Thomas worked for his uncle, who was a carriage maker. After losing two children, the Ramells were fraught with worry when little Elizabeth became gravely ill. A Salvation Army captain called on the desperate parents and asked if she could be

alone with Elizabeth to pray. Before she left their home, Thomas told her if his daughter survived, he would join the Salvation Army.[53] Elizabeth recovered, and her father kept his promise. He became a founding member of the Folkestone Salvation Army and formed its band. Over the years, he was to become revered as "Bandmaster Tom."

The sinking of the *Titanic* was yet another unfortunate event in a string of misfortunes for Elizabeth. In 1901, her first love fell into the sea from a Folkestone pier and drowned. Then, on December 26, 1904, she married Edward Ernest Nye of Folkestone, a member of her father's Salvation Army band. Less than two years later, their only child, Maisie, died at the age of nine months. Wanting to get a fresh start, the couple both took jobs in 1907 with the Salvation Army, which was becoming a well-recognized church in the New World. The Nyes went to live in Canada, but two years later, they moved to New York City, where they secured employment at the Salvation Army headquarters on Fourteenth Street. Edward worked as a janitor, and because of her dressmaking skills, Elizabeth landed a job in the Tailoring Department, where the uniforms were made.

After Edward Nye died unexpectedly from a heart condition in 1911, his grieving young widow returned to England to visit her parents. After Salvationists in the United States urged Elizabeth to come back, she was scheduled to travel on the *Philadelphia*, but the crossing was cancelled due to a coal strike. She was then booked on the RMS *Titanic*, quite an exciting change of plans, as it was the maiden voyage of the world's largest and most luxurious ship.

Elizabeth shared Cabin F33 with three other single women. The voyage was uneventful for her until about 11:40 p.m. on April 14, when she and her roommates were settled in their cabin and heard the ship graze a massive iceberg. At first, they didn't think it was too serious, but soon they found themselves on deck in lifejackets, needing to evacuate the badly damaged vessel. Sensational stories abound of how the lifeboats were loaded. "Ladies and children first" was the well-known seafaring "rule" at the time. Elizabeth was one of the survivors, mostly women and babies, in Lifeboat No. 11 who were rescued by the *Carpathia* some five and a half hours later.

When the *Carpathia* arrived in New York, members of the Salvation Army were on hand to comfort the weary survivors. The Salvation Army's publication, the *War Cry*, described the Cunard dock on April 18 as "the scene of the most profound human agony that the mind can possibly conceive." A young Salvation Army bandsman, Captain George Darby, was at the pier to aid *Titanic* passengers. After the ordeal, Elizabeth settled back into working for the Tailoring Department and entered into

a relationship with the handsome Darby. Five years earlier, Darby's wife, Margaret, a Salvation Army officer, had passed away along with their first child during the late stages of pregnancy. A newspaper story romanticized George and Elizabeth's meeting as "love at first sight." However, it seems that their families had known each other back in England, and she and her late husband had known George while living in America. They all shared a common bond, the Salvation Army's inspiring band music.

Elizabeth and George had both been through hardships and appeared to be destined for each other. They wanted to get married, but it was forbidden at that time for a commissioned rank officer and a soldier to marry. So Elizabeth set out to be an officer, received training for the position and succeeded.

On November 19, 1913, George and Elizabeth were married at the Salvation Army Chapel in New York. The newlyweds settled into a roomy apartment in the Bronx but spent their weekends and vacations at Belmar on the New Jersey Coast. One reason they chose Belmar was because they could stay at the Kensington Home of Rest, a vacation boardinghouse at 207 Thirteenth Avenue exclusively for Salvation Army personnel. Elizabeth likely had a fondness for the New Jersey seaside community, as it reminded her of Folkestone. The Salvation Army was active in the local area, and the Darbys could attend services at its citadel in nearby Asbury Park.

The Darbys enjoyed fun-filled weekends and vacations at the beach and boardwalks of Belmar and Asbury Park. Elizabeth didn't want to dwell on her past and avoided discussing the *Titanic*. She had

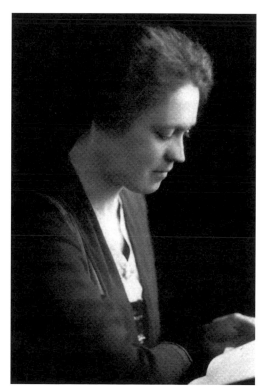

A portrait of a thoughtful Elizabeth Nye Darby.
Jerilyn Sunlin Collection; courtesy of Dave Bryceson's book, Eizabeth Nye: Titanic Survivior.

moved on with her life. On March 30, 1915, Elizabeth gave birth to a healthy baby boy. His proud parents named him George Raymond Darby but called him Ray to distinguish him from his father. Little Ray was a bright boy who loved science and swimming. As a teenager, he began working as a Belmar lifeguard stationed at the Sixteenth Avenue beach. Under the wing of the famous guard Howard Rowland, Ray continued lifesaving duties for many years.

Belmar's glorious beach and the boardwalk with its pavilions provided so much joy for the Darby family. They adopted an Airedale terrier at a New York shelter, and Ray named him "Pal." When Ray went swimming at Belmar, Pal would even doggie-paddle alongside his young master. Elizabeth loved Pal dearly but was said to gently scold him and ask him "to whisper." She'd always give him a treat when he obeyed.

Despite the Great Depression, Elizabeth and George, along with another couple, were able to purchase real estate in Belmar. They had a duplex, 315A and 315B, constructed on their Thirteenth Avenue property. In the rear, George constructed a bungalow so that the main house could be rented and they'd still have room to stay. The Darbys enjoyed the short walk to the beach and made friends with their neighbors. Life was good at Belmar.

On September 8, 1934, the *Morro Castle* disaster just off the New Jersey coast made world news. The Ward Line cruise ship caught fire on its return voyage from Havana, Cuba, to New York, and 135 lives were lost. Being so near to this

Curiosity seekers went to see the *Morro Castle* after it caught fire and was beached at Asbury Park in 1934. Although she was never on this ship, the tragedy was likely a grim reminder of the 1912 *Titanic* disaster for survivor Elizabeth Nye Darby, who lived in Belmar. *Photo by the author's father.*

tragedy must have rocked Elizabeth's peaceful world at the Jersey Shore. Her reaction to it is not recorded, but one can assume that as a *Titanic* survivor, it had to have been especially upsetting. Volunteers with boats from coastal towns including Belmar responded to the horrific event. The Salvation Army likely provided aid to the survivors as they were brought in. The *Morro Castle* ended up beached at Asbury Park, and its burned out hull attracted thousands of onlookers. The cause of the fire remains questionable and mysterious to this day.

From the chaos on board the doomed *Titanic*, stories of both heroism and selfishness have evolved. All the survivors have since passed away, and although most of the eyewitness accounts are well documented, no one can say for sure whether they are totally accurate. We can only put together the bits and pieces of information, leaving many conflicting conclusions to surface. The disaster has been the subject of books, movies, exhibitions, games and merchandise, as well as online blogs and forums. The popularity of the *Titanic* has reached legendary proportions. But it must be remembered that although it might seem like a fascinating tale, the tragic event was real.

Today, we can even relate to someone who was on the *Titanic* and adopt his or her persona for a day, as "boarding passes" of individual passengers are given out to visitors at the official *Titanic* exhibitions. Elizabeth Nye is the subject of one of those cards. At the end of the exhibition, visitors can find out if the passenger on their pass lived or died.

Elizabeth's *Titanic* experience is known, but her work with the Salvation Army and her years at the New Jersey Shore are not familiar to many. She loved Belmar and Asbury Park. She wanted to live quietly and happily by the sea without constantly recalling the horrific events of April 15, 1912. And yet how could she ever forget? How could anyone forget?

In the early 1950s, Elizabeth and George decided to sell their New York abode and move full time to Belmar. They had to downsize considerably. Still dynamic, they helped neighbors and were active members of the Salvation Army Corps at nearby Asbury Park.

In 1961, their health failing, Elizabeth and George moved into the Salvation Army Home for Retired Officers in Asbury Park. On November 22, 1963, the same day as the assassination of President John F. Kennedy, Elizabeth passed away. George Darby continued to live at the Asbury Park home until he, too, was "promoted to glory" in 1968. A simple inscription on Elizabeth and George's tombstone at Kensico Cemetery in Valhalla, New York, describes them as "Gallant Christian Pilgrims." Elizabeth needs to be remembered not only as a *Titanic* survivor but also as a caring and dedicated Salvationist who had great love for her church and her family.

On a bureau in her Belmar house, Elizabeth used to display souvenirs she brought back from visits to her hometown. She could not have imagined that twenty-four years after her death, the little porcelain Folkestone watering can would be found at the graveyard of the *Titanic* and would be displayed at *Titanic* exhibitions around the world.

The complete story of Elizabeth Nye Darby's life is told in the thoroughly researched biography *Elizabeth Nye: Titanic Survivor* by Dave Bryceson.

More information and details about the *Titanic* and its passengers can be found at www.encyclopedia-titanica.org.

THE GOOD DOCTOR: MARGARET MACE

"There is no place on earth like my home town; no people like my home people…I came here when it was wilderness…it is one of the finest places in the world…in my work, I tried to do my best, but I had help, helped by the hand of God."[54]

Here's an eye-opener: Dr. Margaret Mace delivered over six thousand babies at Wildwood during the first half of the twentieth century. It is said that Dr. Mace didn't receive money from patients who couldn't afford to pay; she simply never turned anyone down. Her medical practice seems so rudimentary in today's complex world of specialists, wonder drugs and medical insurance dilemmas, but she did her best. She delivered all those babies, and she saved many lives.

Maggie, as she was affectionately called, was born in Leicester, England, in 1871. She sailed to America with her parents in 1874. The family lived in Philadelphia for a few years but soon moved to Anglesea (North Wildwood). They stayed in the lifesaving station at Hereford Inlet while Maggie's father built a house for his family using lumber recycled from the buildings of the 1876 Philadelphia Exposition. Maggie went to a one-room schoolhouse and then attended Bridgeton Institute. She returned to Anglesea to teach elementary school at a new two-room school that replaced the one she had attended.[55] Although she liked teaching, Maggie wanted to be a nurse. But nurses were not always treated as professionals in those days and were given lowly tasks to perform. Maggie decided she'd become a doctor, which was quite a feat for a woman at that time. Despite many obstacles, she earned a

Dr. Margaret Mace of Wildwood upon graduating from the Women's College of Medicine in Philadelphia, 1905. *George F. Boyer Museum, Wildwood Historical Society.*

medical degree in 1905 from the Women's College of Medicine in Philadelphia.[56] Maggie returned to the New Jersey Shore and opened up a practice in North Wildwood at Seventeenth and Pennsylvania Avenues, later moving to Chestnut and New Jersey Avenues. She was one of the few female doctors in south Jersey at that time.

The growing Wildwood area needed a hospital, and in 1915, Dr. Mace opened one in a large house at Twenty-fifth and Atlantic Avenues that was vacant for a few years and in disrepair. The home had belonged to a prominent Five Mile Beach businessman and real estate tycoon named Frederick Sutton who was a victim of the *Titanic* disaster in 1912. Sutton was returning from a vacation and traveling first class from Southampton to New York on the *Titanic*. When the luxury liner hit an iceberg and sank, many gentlemen, such as Sutton, perished after allowing the women and children to go into the lifeboats first.

Maggie possessed incredible compassion and skill in the healing arts. Local fishermen had great respect for Dr. Mace, whom they relied on to treat a variety of sea-related ailments and accidents. She is said to have successfully treated a man who had his arm nearly severed by a man-eating shark. The man's name was Gus Peterson, and he was working on a Union Pound Company boat. In another incident, Maggie proved how dauntless she was when she hiked up her skirt, crawled underneath a train and treated a man who was pinned beneath the cowcatcher. Casualties from shipwrecks and victims of automobile accidents were treated at the Mace Hospital. The number of accident cases had increased as the number of automobiles

mushroomed. There are countless testimonials about how the good doctor helped so many people.

One incident that's become legendary occurred during a snowstorm in 1935. Maggie reportedly rode on horseback to help a mother in labor when roads were impassible to vehicles. Police captain Louis Fiocca later related that he was on the midnight shift and couldn't get his car out from the snow when he got a call from a screaming woman about to give birth. Fiocca walked to the Mace Hospital. "After waking Maggie up and telling her the problem, she started throwing stuff in her leather bag."[57]

In front of the hospital, there was a horse-drawn milk wagon stuck in the snow. According to the police captain, "We unhitched the horse and [I] helped Maggie on his back. I am deathly afraid of horses, [but I] climbed up in back of Dr. Mace, put one arm around her and, holding the leather bag with the other hand, we start[ed] for Davis Ave." They rode together in the blinding snow. The baby had already arrived when they got there, but at least Dr. Mace was able to check out the mother and baby, both of whom were fine. The police captain never forgot that night. When informed much later that Maggie was sixty-five years old at the time, he wasn't surprised.[58]

"For the past ten years, the Five Mile Beach Sun, Wildwood, NJ, has been honoring the legacy of Dr. Margaret Mace with this eventful photo shoot, where a handful of the 6,000 babies she delivered gather together for a reunion every July at the Hereford Inlet Lighthouse." *Photo of the 2014 reunion by The* Sun's *editor, Dorothy McMonagle Kulisek.*

Dr. Mace never married or had children, but her patients were, in a sense, "her children." She received many honors, and a local elementary school in Wildwood was renamed for her. In 1950, when the Burdette Tomlin Memorial Hospital at Cape May Courthouse (now the Cape Regional Medical Center) opened, Maggie decided it was time to retire. She died the following year at the age of eighty-one. Dr. Mace's hospital, which was also her home, was sold in 1952. It operated as a guesthouse for a while but was razed in 1960 to make way for a motel.

A permanent display about Dr. Margaret Mace with photos and memorabilia can be seen at the George F. Boyer Museum in Wildwood. Her original black leather medical bag that she carried to make house calls is the centerpiece of the exhibit. The down-to-earth way that the remarkable Dr. Maggie practiced medicine might seem outdated today, but her skill and bedside manner are not forgotten.

Each summer since 2005, the "Mace Babies" (people who were delivered by Dr. Mace) get together for a fun-filled reunion. Dorothy Kulisek of North Wildwood, an artist and publisher of the *Sun by the Sea* newspaper, started the event. Although she's not a Mace baby herself, she has great respect and admiration for the good doctor.

JOY OF THE NAVY: JOY BRIGHT HANCOCK

"The women in the Navy, as did those in the other military services, by their successful performance of duties, contributed mightily to the sociological picture of women in the twentieth century. In fact they created a new evaluation of the worth of womanpower."[59]

Born in Wildwood in 1898, a plucky red-haired girl named Joy Bright grew up to pave the way for women's equality in the military. She served in the U.S. Navy during both world wars and became the third and last director of WAVES (Women Accepted for Volunteer Emergency Service), a nickname for the Women's Reserve of the U.S. Naval Reserve. Hancock was instrumental in passing the 1948 legislation that gave women permanent status in both the regular and reserve navy. (This was the same year that President Truman signed an order to desegregate the military.)

Her name, Joy, supposedly compensated for the fact that she was the third girl born to her parents when her father was hoping for a boy. He would hold

her and say, "We called her Joy because she came to teach the meaning of that name. She is a girl, not a boy, and best of all, she is my Joy."[60] The next three of the six children born to the Brights were all boys.

Joy's father, William Henry Bright, the son of English and Irish immigrants, left Philadelphia in 1882 to live in Wildwood. He worked to establish its untamed seashore as a resort. A most ambitious man, he sold real estate, became a banker and participated in community affairs. Bright was elected sheriff of Cape May County in 1904. Later on, he would serve as mayor of Wildwood, a New Jersey state senator and president of the senate. Joy's mother, Priscilla Buck, a skilled dressmaker, came from a Pennsylvania dairy farm. Priscilla met William Bright in 1891 while

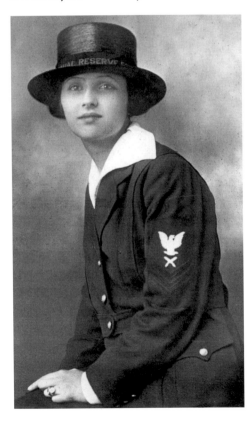

she was vacationing with her evangelist brother and his wife, who lived in Wildwood. William was twenty-nine and Priscilla nineteen when they married the following year. According to Joy, her parents had a "remarkable relationship" and shared the responsibilities of both work and family. They supported the cause of women's suffrage, and when William Bright became sheriff, he even designated his wife as his unofficial deputy.[61]

Priscilla Bright campaigned for women's suffrage. Well-known activists for women's rights including Carrie Chapman Catt and Jane Addams were said to visit the Bright home in Wildwood and "helped inspire Joy Bright and her two sisters to seek uncommon goals."[62]

Yeoman First Class (F) Joy Bright in February 1918 while she was serving in the Office of the Naval Superintendent of Construction, New York Shipbuilding Corporation, at Camden, New Jersey, during World War I. *U.S. Naval Historical Center.*

Joy performed many traditional "boy" tasks such as mowing the grass and cleaning out the ashes from the coal furnace. Her grandfather Bright, who lived

with the family, taught Joy carpentry. She became proficient with tools and at painting. When the family got a Hupmobile, Joy learned how to fix flats and make repairs. The skills she developed as a child would eventually help her prove that women could perform mechanical and technical jobs in the navy as well as any man.

After graduating from Wildwood High School in 1916, Joy attended a business school in Philadelphia, where she acquired secretarial skills. In 1918, she enlisted as a yeoman (F), which was a temporary classification for women in the U.S. Navy during World War I (the "F" was for "Female"). At first, she was a courier at a Camden shipyard, but soon, as a chief yeoman, she worked at the Cape May Naval Air Station. By the end of 1919, the female yeomen had been mustered out. Much later, Joy said, "As I look back to World War I, I need to stress that 10,000 Yeoman (F)…served ably as translators, draftsmen, fingerprint experts, camouflage designers, and recruiters."[63]

After the war, Joy remained at the Cape May Naval Air Station as a civilian employee, helping to decommission the site. In 1919, while she was working at Cape May, Joy met Lieutenant Charles Gray Little, an attractive Harvard graduate. It didn't take long before they fell in love. Little, a recipient of the Navy Cross, had flown dirigibles in France during the war. Later, when he was called to receive additional rigid airship training in England, Joy traveled there to be with him. They were married on October 9, 1920, in Yorkshire, England. Tragically, before they even celebrated their first anniversary, Charles Little died when his dirigible ZR-2 exploded and crashed in the River Humber at Hull, Yorkshire, on August 24, 1921.

Joy returned to the United States and took a job as a civilian clerical worker at the Bureau of Aeronautics in Washington, D.C. She edited the bureau's newsletter, which later became *Naval Aviation News* magazine. She was interested in learning more about lighter-than-air ships and transferred to the Naval Air Station at Lakehurst, New Jersey. She began work as a stenographer-clerk in December 1923. It wasn't long before the young widow met Lieutenant Commander Lewis "John" Hancock, a Texan and graduate of the U.S. Naval Academy. Joy and John were married on June 3, 1924, in a small ceremony at her parents' home in Wildwood. They soon set up housekeeping at Lakehurst. Then, in a horrible twist of fate, Hancock was killed when the rigid American airship *Shenandoah* crashed in Ohio during a storm on September 3, 1925.

The death of her second husband, less than three years after her first husband died, brought Joy extreme emotional and physical pain. She was hospitalized for almost a year for an infection that caused some temporary paralysis. Upon her recovery and discharge from the hospital, Joy and her sister Eloise took

a six-month cruise to Asia and the Middle East, ending up in Europe. It was in Cairo that Joy met an American naval officer named Ralph Ofstie. They enjoyed some time together, but little did Joy know that she'd meet up with Ofstie again many years later. The two sisters wanted to learn French, and they shared an apartment in Paris for a while. They also took classes at a branch of Parson's New York School of Fine and Applied Arts.

When Joy returned to the United States, she thought she'd like to work for the U.S. State Department. She'd seen a lot of the world and had a desire to see even more. In 1928, she studied for two years at the Crawford Foreign Service School in Georgetown. She took the State Department's exams and passed the written tests but failed the oral exam, a disappointment that she called "a bitter blow to my pride."[64]

Always wanting to learn something new, Joy decided to take up flying. Aviation, both military and commercial, was progressing rapidly. She was afraid to fly, but her way of overcoming fears was to face them head on. While attending the Crawford School, she took flying lessons and received a pilot's license. She then worked in a civilian job for Rear Admiral William A. Moffett at the Bureau of Aeronautics. Moffett admired Hancock and

appointed her as his special assistant and civilian chief of the bureau's General Information Section. In yet another sad twist of fate, Joy's caring boss Moffett was killed when the dirigible *Akron* crashed off the coast of New Jersey on April 4, 1933. Devastated once again by tragedy, Joy took another journey to the Far East and then stayed in Europe for a while. Travel always seemed to soothe her soul. She returned to the Bureau of Aeronautics in 1934 and worked in press relations. She edited the bureau's weekly newsletter, and in 1938, she wrote a book, *Airplanes in Action*.

When the United States entered World War II in 1941 and additional forces were needed, leaders of the Bureau of Aeronautics were more

Captain Joy Bright Hancock of the U.S. Navy, 1940s. *George F. Boyer Museum, Wildwood Historical Society.*

inclined to consider including women in the navy. Although many older admirals rejected the idea, Congress authorized WAVES in 1942. The first director was Mildred McAfee, president of Wellesley College. On October 23, 1942, Joy Hancock became a lieutenant in WAVES, one of the first officers appointed. She received a promotion to lieutenant commander on November 26, 1943, and became commander on March 5, 1945.

Some navy officers felt that WAVES should work only as clerks. Hancock insisted that women could work in many different jobs. By the end of World War II, eighty-six thousand WAVES were serving in a variety of positions such as radio and telegraph operators, photographers, control tower operators, aviation instructors and machinists.[65]

A highpoint in Joy's life was when she became the first WAVES officer to christen an American warship. In 1943, at Kearny, New Jersey, she had the honor of christening the destroyer SS *Lewis Hancock*, which was named for her second husband.

Joy worked diligently to draft legislation that would bring WAVES into the permanent peacetime navy and naval reserve. It was a tough battle, and she was up against opposition from a number of military leaders and members of Congress. Hancock even had to address concerns from Congress about such sensitive issues as menopause. Using documentation from the surgeon general of the navy, she managed to prove that "menopause was not a physical disability."[66] Her efforts were successful, and the Women's Armed Service's Integration Act was passed by Congress in 1948. President Truman approved and signed the legislation in July of that year. Hancock became "one of the first six women to receive a regular commission."[67] She served as "an advisor on women's affairs" and helped to expand the number of WAVES during the Korean conflict (1950–53).[68]

After her mandatory retirement from the navy in 1953 at age fifty-five, Joy Hancock had a home built in St. Croix. She loved living in the Virgin Islands, but heavy rains caused damage to her property, and she returned to Wildwood in 1954. While at St. Croix, Joy had visits from many old friends, including Lieutenant Ralph Ofstie, whom she had met in Cairo while traveling in the 1920s. During the summer of 1954 at Wildwood, Joy became close with Ofstie. They married in August and wanted to return to St. Croix, but Ofstie wasn't quite ready to retire. He accepted a position as commander of the Sixth Fleet, which operated in the Mediterranean. Joy enjoyed being Ofstie's wife and said, "Retirement had not separated me from the Navy."[69]

Ralph Ofstie became ill in 1956 and returned from Europe to be treated at the naval hospital in Bethesda, Maryland. Once again, Joy would become

a widow when Ofstie died a few months later. She was comforted by her memories of the wonderful year they spent together in the Mediterranean.

In 1967, "President Lyndon B. Johnson signed a bill which removed the restrictions of rank for all women in the armed services."[70] This was a glorious moment for Captain Hancock, who was presented to President Johnson at the White House. Hancock won numerous awards and honors throughout her career for her outstanding service during two world wars and beyond.

When she returned to Wildwood in 1962 to take care of family business, Hancock worked on writing a memoir, *Lady in the Navy*, which was published in 1972. She spent her final years in the Washington, D.C. area, dying there on August 20, 1986, at the age of eighty-eight. She is buried with her third husband, Admiral Ofstie, at Arlington National Cemetery. Despite the tragedies she endured, the remarkable little redhead from Wildwood made great strides to establish equality for women in the military.

A section of Wildwood's George F. Boyer Museum (www.wildwoodhistoricalmuseum.com) is dedicated to Joy Bright Hancock. The display includes photographs and memorabilia of her Wildwood days, as well as many items from her naval career.

Chapter 5

WRITERS, ARTISTS AND ENTERTAINERS

"THE CRICKET": MAGGIE MITCHELL

"Hallo, there's my shadow! (merrily) Come hither, my black companion, I have no other dancer. Let's see what we can do (she sings, beats the time, and moves her arms in the air and dances)."[71]

The dynamic Margaret Julia Mitchell ranks as one of the greatest American performers of the nineteenth century. And yet most people do not recognize her name today. She played her signature role of young Fanchon the Cricket for over thirty years, starting when she was twenty-eight and continuing until she was around sixty. Fanchon's "shadow dance" was a sensation with theatergoers. The stage was Maggie's lifeblood, but when she had time off, she spent it at the New Jersey Shore. She owned property in the Long Branch area, both for her own pleasure and as an investment.

In the days before air conditioning, city theaters shut down for the summer, and the performers flocked to the Jersey coast. Although the theater folk were seeking rest and recreation, they also conducted rehearsals and appeared in benefits for local charities. Theatrical colonies, clusters of stage stars' cottages, dotted the Jersey Shore. The largest one was in Long Branch during the mid- to late nineteenth century. In the halcyon days of the actors' summer sojourns, the area where they lived was still surrounded by undeveloped countryside. Their properties were slightly west of the ocean and away from the hubbub of the posh hotels and gambling houses.

Stage star Maggie Mitchell performing her famous "shadow dance" from *Fanchon, the Cricket.* The illustration is from an original theater program, circa 1870s. *Author's collection.*

Maggie Mitchell was among the dozens of celebrities who summered here. Her neighbors included such notables as Edwin Booth, Lillie Langtry, the Wallacks, Mary Anderson and Lillian Russell.

Born in New York City in 1837, Maggie came from a theatrical family. She was on the stage from the time she learned to walk. Her father was an actor-manager, and she appeared in many productions as a child. As a teenager, she played boys' roles, including Oliver Twist and Edward, the young Prince of Wales, in Shakespeare's *Richard III*. In the early years of her career, a "Maggie craze" swept the nation, started by some young men in Cleveland. Over the years, she also portrayed many well-known female characters, including Jane Eyre. But her favorite role was the young heroine of Fanchon the Cricket. The play was based on an adaptation of *La Petite Fadette*, an 1849 romantic novel by French female author George Sand.

Maggie was reportedly a favorite of President Abraham Lincoln, who often attended her performances. The performer, whose roots were in

New York, was known to be a devoted Yankee. When the Civil War ended, she was playing in Mobile, Alabama, and bragged to friends that she was "the first woman to raise the Stars and Stripes in Mobile." Maggie has been romantically linked to actor John Wilkes Booth, Lincoln's assassin. But there seems to be no concrete evidence to back up this supposition. When Booth was killed, several *cartes de visite* of actresses were found on his body. Some people say that one of them was of Maggie. However, this does not appear to be correct, as none of the photos resemble Maggie. Booth and Mitchell might have performed together or at the same theaters, but their relationship was likely a purely professional one.

A *carte de visite* of actress and entrepreneur Maggie Mitchell, circa 1870. *Author's collection.*

Maggie's first cottage at Long Branch was on Cedar Avenue, west of Norwood Avenue, in an area that is now part of Monmouth University. She and her manager-husband, Henry T. Paddock, summered here with their children, Fanchon (she named her daughter after the character from the play) and Harry. In 1875, Maggie purchased actor James McVicker's cottage, Meershaum Villa, near the southwest corner of Park and Norwood Avenues (now Ocean Township). The cottage was the site of the 1869 marriage of actor Edwin Booth (John Wilkes's brother) and McVicker's daughter, Mary. When Maggie acquired the McVicker cottage, it became known as Cricket Lodge. At this cozy home, she entertained theatrical friends for decades.

In 1888, Maggie's twenty-year marriage to Harry Paddock ended in divorce. The following year, she married Charles Abbott, a leading man who had performed with her on stage for many seasons. Maggie was fifty-one when she married Abbott, and he would become her manager. In the theatrical world of the Victorian era, women could have some influence,

Cricket Lodge, Maggie Mitchell's house on West Park Avenue in Long Branch (now Ocean Township), early 1900s. *Author's collection.*

unlike most other professions, which were ruled by men. Even though Abbott was her manager, she was the director of her company and had control over business decisions.

The hardworking "Cricket" owned many of the plays she produced and made sure she secured the rights to *Fanchon*. She scouted for talent, looking to publish successful new plays. Aspiring playwrights sometimes contacted her, hoping she might produce their work. Maggie also had a talent for buying investment property and owned quite a few lots in Long Branch during the 1870s, which can be seen on old maps of the area as belonging to "M.J. Paddock." She might also have used some other names.

Several of Maggie's relatives were also performers. Her half sister, Mary Mitchell, was also an actress and lived in Long Branch. Mary was married to theater producer James Albaugh, and they lived on the north corner of Cedar Avenue, west of Norwood Avenue (next to what is now the Monmouth University Guggenheim Memorial Library). One of Maggie's nephews, actor Julian Mitchell, became famous as a director and producer.[72] He directed the first stage version of *The Wizard of Oz* in 1903 and directed a number of Ziegfeld Follies shows. Julian and

his much younger wife, dancer Bessie Clayton, lived in a mansion on Norwood Avenue in Long Branch.

Maggie Mitchell finally slipped out of favor with the public in the late 1890s, when entertainment was changing and movies began: "Alas! The characters and the plays which served to make Maggie Mitchell so great a favorite with father and mother and so much beloved by every child are no longer in fashion. Such things are too tame for the present day, since the rising generation of playgoers craves more highly seasoned food."[73]

Maggie died on March 22, 1918, at her New York residence at the age of eighty-one. She had been suffering from a lingering illness due to a fall she had taken at Cricket Lodge the previous summer. The warm months of her final years were spent in the area she loved so much, the New Jersey Shore. Her family members and friends would often visit to go bathing at the nearby beaches and to take carriage rides in the country.

Though she was truly remarkable, Maggie is not well remembered today. However, she was an American idol in her era and a successful entrepreneur. Cricket Lodge was not preserved; the house has been totally remodeled over the years and is unrecognizable today. But the spirit of the indomitable Cricket keeps on chirping.

THE IMPRESSIONIST: CARRIE COOK SANBORN

No great artist ever sees things as they really are.
If he did, he would cease to be an artist.
—Oscar Wilde

The area that is now Point Pleasant, once inhabited mostly by shorebirds and fish, was a haven for summer tourists in the nineteenth century. It was the site of a flourishing nineteenth-century artists' colony headed by Carrie Cook Sanborn. At the Cook Homestead, a picnic grove known as the Cedars provided an ideal setting for painters to work *en plein air* (in the open air) creating landscapes.

In 1792, Quakers Thomas Cook and his wife purchased three hundred acres of land on the New Jersey coast from William Curtis. On this isolated property, Cook constructed a simple one-story farmhouse that was expanded and became known as the "Cook Homestead." The family farmed and raised mostly corn and hay but wasn't making enough money, so they decided to

Nineteenth-century Manasquan River–area artist Carrie Cook Sanborn working on a self-portrait, circa 1870s. *Courtesy of the Point Pleasant Historical Society.*

open a boardinghouse. In 1831, the Cook family added some cottages, a barn and stable, an icehouse and a pump house. Thomas Cook Jr. took over the business and ran it until the 1880s.[74]

The Cook boardinghouse attracted guests who enjoyed swimming and fishing in the Manasquan River, Cook's Pond (Lake Louise) and the Atlantic Ocean. Sportsmen's clubs for fishermen and hunters popped up along the secluded shores away from the noise of the rapidly developing resort cities. After the Civil War, more and more big hotels and amusements were being constructed, and transportation improved, bringing an influx of vacationers to the New Jersey coast. But some visitors still preferred the great outdoors and quiet to the social whirl and clamor of the big resorts. It wasn't all about gunners and fishermen at the Cook Homestead. Artists found the place to be a sanctuary where they could observe nature as they sketched and painted. Writers also realized the benefits of the area for contemplative study and composing.

The success of the Cook property as a retreat for artists came about thanks to Carrie Cook. Born in 1843, Caroline Virginia Cook was the youngest of Thomas and Ann Cook's twelve children. Carrie performed daily chores such as feeding the chickens and milking the cows. When she had any chance for fun, she rode her pony. On clear days, the observant young Carrie would gaze at the ships that sailed by the inlet, and sometimes she witnessed the wrath of storms, especially because her uncle was the wreck master. She went to Quaker meetings with her father, and in the winter, they'd have to trek across the ice to Squan Village (Manasquan) in order to attend.[75]

It was apparently love at first sight when Carrie met Nestor Sanborn, a bank clerk from New York and a summer boarder at the Cook farm, in 1869. Carrie and Nestor had a common interest in art, and only a week after they met, he asked her to marry him.[76] The fact that she would live with him in New York, where she could formally study art, was no doubt a mitigating factor in her quick acceptance of his proposal.

In 1870, Carrie began formal art lessons at the Cooper Art Institute and proved to be an outstanding pupil. It wasn't long before she was instructing others, and she opened a studio at the nearby Bible House. At the Sanborns' home in Brooklyn, artists, art dealers and collectors from all over the world gathered to discuss art on Sunday afternoons. At Carrie's Bible House studio, she taught classes and hosted exhibitions. Carrie also taught disadvantaged students and gave classes for female inmates at a Brooklyn jail.[77]

The popular teacher took her students on summer field trips to Point Pleasant and Manasquan, where they sketched and painted outdoors. They enjoyed art sessions in the morning and swimming in the afternoon. Although she kept her home in Brooklyn and studio in Manhattan, Carrie longed for the New Jersey Shore where she spent her youth. Her parents' property was taken over by the town in the 1880s. Around the end of the nineteenth century, the former Cook land was purchased by the Reed family, who sold some of it as lots and made the rest of it into a golf course. It remained a golf course until World War II, when the property was again taken over by the town. Most of it was later purchased by the board of education, and the site of the farmhouse became a school. The Cedars, where artists once painted *en plein air*, became a high school athletic field.[78]

Carrie and Nestor decided to buy land in Point Pleasant and built a home adjacent to the old Cook Homestead. They called the home Manasquan Cottage and spent their summers there, taking in boarders to pay the expenses. The place was a popular retreat for years. After recovering from tuberculosis around the close of the nineteenth century, Nestor became a full-time art dealer and filled the Jersey Shore house with many antiques. The home burned down a few years after Carrie's death in 1934.[79]

The Sanborns befriended many artists, but perhaps the most famous figure to cross their path was author Robert Louis Stevenson. On Stevenson's second voyage to America, he stayed at Saranac Lake, New York, and then spent about a month in Brielle, New Jersey. The main reason for Stevenson's visit was apparently to improve his health. He visited Osborn Island in the Manasquan River and called it "Treasure Island" after his popular 1883 novel.[80]

In 1888, on the last day of his stay in the Manasquan area, Stevenson attended a farewell party hosted by Carrie and Nestor Sanborn at their Point Pleasant home. The Sanborns and an impressive group of well-known artists toasted Stevenson and waved goodbye when he left in a rowboat to cross the river. He then boarded a waiting carriage.

The impressionists who painted in New Jersey have been recognized more in recent years. Roy Pederson's stunning hardcover book *Jersey Shore Impressionists: The Fascination of Sun and Sea, 1880–1940* is the definitive work on this subject. Pederson is an art dealer and historian in Lambertville, New Jersey. Three paintings by Carrie Cook Sanborn are among the many works reproduced in his book. Pederson's book also includes chapters about several other female impressionists at the New Jersey Shore, including Ida Wells Stroud and Clara Stroud, mother and daughter, who created an amazing body of work. In 2013, an exhibition of the Jersey Shore paintings was held in conjunction with the book at Morven Museum and Garden in Princeton.

Myriad artists—both professional and amateur, women and men—work along the New Jersey coast today. It would be impossible to list them all here. The sea, sand and salt marshes, as well as the colorful boardwalk amusements, are all exciting subjects. Art studios and galleries are found in most every seashore town along the Jersey coast. Remarkable artists of the past such as Carrie Cook Sanborn paved the way for today's artists and left a legacy of work for all to enjoy.

A Romantic Writer: Margaret Widdemer

We are not bored; blasé, a little perhaps, with the tawdrily exciting summers we have known since babyhood. But the Boardwalk is our life; and one doesn't make amiable compliments about one's life.
—The Boardwalk (1920)

In today's fast-paced world, few people recognize the name of Margaret Widdemer, an American poet and novelist who won the 1919 Pulitzer Prize (then known as the Columbia University Prize) for her collection of poems titled *The Old Road to Paradise*. She shared the honor with Carl Sandburg, who won for *The Corn Huskers*. Sandburg's name is familiar today, but Widdemer has been terribly forgotten. The style of her writing

A rarely seen portrait of Asbury Park's Pulitzer Prize–winning author Margaret Widdemer from the early 1900s. *Author's collection.*

might seem outdated, but her work still has merit and reflects the talent of this complex and prolific woman.

Margaret was born on September 30, 1884, in Doylestown, Pennsylvania, but spent her formative years in Asbury Park, where her father was minister of the First Congregational Church on First Avenue and Emory Street. She developed a keen awareness of the world around her early in her life, and she possessed a flair for writing. Life at the New Jersey Shore provided the impetus for many of Widdemer's poems and stories.

Her mother and aunt ran The Breakers, a hotel located near the ocean on Second Avenue. Margaret was homeschooled at the family's residence on Grand and Seventh Avenues until she entered Asbury Park High School. It is said that she composed her first poem, "Asbury Park Goldenrod," at the tender age of four. She studied at the Drexel library school in Philadelphia.[81]

As an adult, Margaret first achieved recognition for her 1918 poem "The Factories," which addressed the problem of child labor. She had nine novels

published while still in her twenties, and her final novel, *Red Castle Women*, was published in 1968, when she was eighty-four years old. During her lifetime, Margaret received awards for both her poems and her novels, although she always considered herself primarily a poet. Some of her fictional works might have been considered bold in their time, but they are mild by today's standards. She also wrote children's novels, including a series about a girl named Winona.

The locales of her fictional stories influenced by the New Jersey Shore are thinly veiled versions of real names. *Why Not?* (1915) begins in "Wanalasset" (Wanamassa), and *The Boardwalk* (1920) is a collection of short stories set in "The Park" (Asbury Park), "Allenwood" (Allenhurst) and "The Grove" (Ocean Grove). In "The Changeling," the opening story in *The Boardwalk*, the author describes the winter months and skating on Sunset Lake. This makes her work particularly interesting, as most fiction about the shore takes place in the summer.

In regard to using one's imagination, Margaret said:

> *What your own existence lacks you put into your novel frankly and unstintingly. For instance, we were living one winter at Asbury Park. It is incredibly lonesome in Asbury in January, with just nothing at all to do but look at the ocean. One day, I decided things were so awful that I'd have to improve them. If I couldn't actually live romance I could create a life for myself in my imagination. So I wrote a book. The book was* The Rose Garden Husband.[82]

A few silent films were based on Widdemer's most successful novels. *The Rose Garden Husband* was made into a 1917 film called *A Wife on Trial*. Her Jersey Shore–based novel, *Why Not?*, was the basis for the 1918 film *A Dream Lady*.

At the time of her only marriage, Margaret was thirty-five and older than most of her main characters. Her husband, a widower named Robert Haven Schauffler, was five years her senior. A Princeton graduate, Schauffler was a well-respected and accomplished author, cellist and tennis player. He composed music and wrote biographies of famous musicians and books about holidays. During World War I, he was an instructor at the officer's training school at Camp Meade in Maryland, and he served in France. The couple, who had much in common as authors, tied the knot at Lake Sunapee, New Hampshire, on August 28, 1919, and spent their honeymoon in Europe. Margaret kept her maiden name for her writing. The marriage ended in divorce, and neither one of them ever had any children.

Widdemer also penned a memoir and books on how to write. In 1937, her instructional work *Do You Want to Write?* was published, and *Basic Principles of Fiction Writing* appeared in 1953. Her absorbing 1964 memoir, *Golden Friends I Had: Unrevised Memories of Margaret Widdemer*, recalls her relationships with a variety of famous authors, including Elinor Wylie, Edward Arlington Robinson, Edna St. Vincent Millay, Ezra Pound, Thornton Wilder and Amy Lowell.

Eventually, Margaret's books went out of print. Though she kept getting published until the close of the 1960s, her popularity had declined after World War II. She died in 1978 at the age of ninety-three. For decades—even into the 1990s—Widdemer's works could be found only at libraries or used bookshops. With the upsurge of the Internet and electronic books, however, her work has become accessible, and a number of her poetry collections and novels have been reprinted. There are some that can even be downloaded for free. Margaret Widdemer's writing does not come across as florid; many modern readers find it to be well crafted and refreshing. In recent years, Asbury Park has recalled Widdemer with readings of her poems at local events.

Some good advice from Margaret: "Work at something you like and it's never a grind, no matter what energy you put into it. The tragedy of the world is that each human being cannot work at what he likes to do. All work would be easy then, and success would be commoner than failure."[83]

"QUEEN OF FEMININITY": MISS AMERICA

"There she is, Miss America..."

Many traditions have changed during the history of the Miss America pageant, which began at the dawn of the Roaring Twenties and continues today. In 1920, a member of the Business Men's League of Atlantic City proposed a "Fall Frolic" to be held in late September. After Labor Day, business slowed down, and something was needed to boost off-season tourism. The frolic didn't happen, but the International Rolling Chair Pageant held in 1920 was a big success. Then someone came up with the idea to add a beauty contest to the parade. During that same year, women achieved suffrage, and Prohibition went into effect. Women's fashions were changing. Bathing suits were more revealing, some even showing bare knees! East Coast newspapers sponsored contests for readers to nominate contestants.

An iconic photo of the first Miss America, sixteen-year-old Margaret Gorman, Atlantic City, 1921. *Atlantic City Free Public Library.*

The young women entered in the first Miss America event in September 1921 represented cities, not states, in an Inter-City pageant. (The pageant gradually transitioned to having women representing states.) Some of the contestants were Miss Camden; Miss Harrisburg; Miss Newark; Miss Philadelphia; Miss Washington, D.C.; Miss Ocean City; and Miss Atlantic City. The young women appeared in a Rolling Chair Parade, wearing elaborate costumes, and in a Bather's Review, in swimsuits. A highlight of the early pageants was the arrival of "King Neptune," who floated onto the beach in a large shell with a bevy of sea nymphs during a spectacular entrance.[84] The surprise winner, known as the "first Miss America," was a petite sixteen-year-old named Margaret Gorman, who represented Washington, D.C.

For the next few years, the September beauty contest expanded and drew big crowds. Nevertheless, it was discontinued from 1929 to 1933 due to financial difficulties and allegedly because some critics thought the event was encouraging immoral behavior. In 1932, a "Miss America" pageant was held at Wildwood, but it was not officially sanctioned by the organizers of the Atlantic City event. The winner was Dorothy Hann, who was known as "Miss America 1932." The Atlantic City pageant started again in 1933 and was very popular during the 1940s and 1950s. It was first televised nationally in 1954. Brains and not merely beauty became important, and finalists had to answer questions about social problems and current events. Many of the women were admired for their accomplishments in untraditional female roles, especially those pursuing careers in math and science.

The 1937 winner, Bette Cooper, was one of only two Miss New Jersey entrants ever to win the official title of Miss America. She was also known as the beauty queen who disappeared. Bette, Miss Bertrand Island, ran off with her male chaperone, possibly in a motorboat, shortly after she was crowned. Even after she was located, she never carried out her term as Miss America. No one replaced her, and she dropped out of the public eye. In 2014, she was reportedly alive and living a quiet life in Connecticut. She has refused to ever give any interviews.

Perhaps the most bizarre story about a Miss America contestant is that of Janice Hansen, Miss New Jersey of 1944. She did not win the crown but achieved notoriety some years later. Janice was suspected of being involved with organized crime bosses and was questioned by law officials. She supposedly had dinner with mobster Albert Anastasia in 1957 on the night before he was murdered. In 1959, former beauty queen Hansen and Anthony "Little Augie" Pisano were shot and killed while sitting in a car in Queens, New York.[85]

There are many interesting "firsts" in the history of the Miss America pageant. The first Native American (Cherokee) to win the title was Norma Smallwood, Miss Tulsa, in 1926. In 1935, the pioneering executive director of the event, Lenora Slaughter, established the first talent competition of the pageant. The first scholarship grant awarded went to Bess Myerson, Miss America 1945, who was the first Jewish woman to win and the first college graduate selected. In 1970, Cheryl Brown became the first African American woman to compete in the event. Miss America 1994, Heather Whitestone, who is "profoundly deaf," became the first woman with a disability to win the title. The 2014 Miss America, Nina Davuluri, was the first winner of Indian American descent. By 1995, more than $100 million in educational grants

Miss America 1926. In Atlantic City, King Neptune crowns the winner, Norma Smallwood, who was Miss Tulsa. The Oklahoman was the first Native American to be Miss America. On the right is Native American Alice Garry, who appeared in the pageant as "Princess America." The Golden Mermaid, a trophy presented to winners of early pageants, is near the foreground. *Atlantic City Free Public Library.*

had been awarded, making the organization the world's largest provider of scholarships exclusively for women.[86]

Miss America has survived as a positive role model for several generations of fans, but the pageant has had its share of controversies. The second wave of the women's movement and civil rights issues heated up in the 1960s.

Miss America needed to change with the times. Protests took place, and the pageant became a target of ridicule and, for some, a symbol of bigotry. In response, the Miss America organization adopted new policies and worked to improve the image of the contest.

At the 1984 pageant, Vanessa Williams, Miss New York, made history as the first African American woman to win Miss America. A scandal developed during her reign because she had posed for photos that were published in *Penthouse*. She resigned, and first runner-up Suzette Charles, Miss New Jersey, took over for the remainder of the year as Miss America. Charles, from Mays Landing, became the second Miss New Jersey to be crowned and the second African American to hold the title. Both Williams and Charles went on to successful careers in the entertainment business.

It was a bitter blow to Atlantic City when the Miss America pageant moved to Las Vegas in 2006. But in 2013, the event returned to the New Jersey resort city that had hosted it since 1921. Boardwalk Hall, known as Convention Hall when it became the site of the pageant in 1940, was the main venue for the event once again.

Numerous books, articles and television documentaries have illustrated the history of the Miss America competition. The organization's official website, www.missamerica.org, provides information about the pageant, its mission and biographies of the winners year by year. The Atlantic City Historical Museum features displays of Miss America memorabilia. Recently, the museum acquired one of the whimsical shoes worn in the Show Me Your Shoes parade by Miss Delaware 2014, Brittany Lewis, who hails from Brigantine, New Jersey.

Miss America 1998, Katherine "Kate" Schindle, was Miss Illinois but grew up in Brigantine, New Jersey. She is one of the winners who went on to a successful theatrical career. The stage and screen actress is well known as an AIDS activist and is the author of a 2014 memoir, *Being Miss America: Behind the Rhinestone Curtain*.

Although it has nothing to do with the official Miss America pageant, an event that has become popular in recent years should be mentioned. Miss'd America, a "drag queen show" that began in 1991, has been described as a "good-natured spoof of the Miss America Pageant."[87] The Greater Atlantic City LGBT Alliance and the Schultz-Hill Scholarship Foundation in association with Caesars Entertainment are the current presenters of the entertaining contest. It's not to be "miss'd!"

Miss America and other beauty pageants have played a big role in the social and economic history of the New Jersey Shore. Many of the winners and contestants are indeed remarkable.

Daredevils on the Steel Pier: The High-Diving Horse Act

Once you were on the horse, there really wasn't much to do but hold on. The horse was in charge.
—Arnette Webster French[88]

With bated breath and pounding hearts, the hushed spectators squirmed in the bleachers at the far end of Atlantic City's Steel Pier. A young woman in a form-fitting bathing suit climbed up the ladder of a forty-foot-high platform. She smiled and waited for a sprightly horse to run up the wooden plank ramp toward her. At precisely the right moment, the skilled rider leaped onto the horse. When the horse hesitated and peered into the tank of water below, the rider did not prod or scold him. When the animal was ready and willing, he nosedived into the water. For a few surreal seconds, the magical duo was airborne as they plunged downward. When the horse, with the rider usually still astride, emerged from the water, the crowds cheered and whistled. The women who rode the diving horses loved what they did for a living.

This stunt, which originated in the Midwest, was performed thousands of times between 1929 and 1978. The high-diving horse act was not only the biggest attraction at the Steel Pier, "The Showplace of the Nation," but an act known around the world. The exact routine and costumes changed only slightly over the years. There were male riders who filled in now and then, but overall, the act remained the same. The audiences paid to see a pretty girl and a fine-looking horse. The stunt was wildly popular, but there was always concern about the safety of the riders and the welfare of the horses.

Sonora Webster became one of the first high-diving horse riders at the Steel Pier. She was born on February 2, 1904, in Waycross, Georgia. Sonora's mother encouraged her to answer a newspaper ad for a diving girl. The employer was a showman named Doc Carver. Hesitant at first, Sonora didn't think the traveling circus life was right for her. But rural Georgia offered few opportunities for a spirited young woman with potential. Sonora needed to make some money. She had a way with horses and loved riding, so she applied for the job.

Doc Carver gave Sonora a chance even though he didn't think she had the strength or body type to ride a diving horse. She was pretty but too slender. Nevertheless, her determination and love of horses earned her the aging showman's approval. She began performing with the show in 1924.

Sonora Webster Carver on the high-diving horse Red Lips at the Steel Pier, Atlantic City, early 1930s. *Atlantic City Free Public Library*.

William F. "Doc" Carver, a sharpshooter, was also a dentist. He had worked with Buffalo Bill Cody's Wild West but moved on to produce his own shows. Carver got the idea for a diving horse act after a wooden bridge he was riding over collapsed beneath him. As the story goes, Carver and his horse plunged into the Platte River in Nebraska but were not injured.

Carver decided to turn this incident into an exciting act. He began to feature diving horses at county fairs. His son, Al, worked as the show's announcer, and his daughter, Lorena, rode the horses. Doc Carver died in 1927, and Al took over the business. When impresario Frank Gravatt, owner of the Steel Pier, heard about the diving-horse show, he thought it could be a sensational attraction for Atlantic City. The act debuted on the Steel Pier in 1929 and was a huge hit.

Al proposed to Sonora not long before she began working in the Steel Pier show. They were married and spent most of their time training and working with the diving horses. In 1931, Sonora's face smacked the water while she was on the horse Red Lips, and she suffered a retinal detachment. Doctors tried to treat her injury but could not save her sight. In Sonora's autobiography, *A Girl and Five Brave Horses* (1961), she describes what it felt like to go irreversibly blind. She tells how she came to accept the challenges of her disability. She never put the blame on anyone—not the horse, the show or herself. She experienced depression but was determined to go on and not baby herself. She practiced how to perform everyday tasks, learned Braille and returned to performing as a diving-horse rider. Although she considered other jobs, riding horses was her passion, and she wasn't about to give it up. For eleven years, she continued to dive despite her blindness.

In 1991, a Walt Disney movie titled *Wild Hearts Can't Be Broken*, based loosely on Sonora's autobiography, was released. The film starred Gabrielle Anwar as Sonora and Cliff Robertson as Al Carver. Although fictionalized and not completely accurate, it became a family classic. The film has brought the real story of Sonora and the diving horses to the public's attention.

Sonora died on September 20, 2003, at the age of ninety-nine in Pleasantville near Atlantic City. Her courageous life story has provided inspiration for young women everywhere and for anyone who needs a role model to keep on going, no matter what life might bring.

Arnette Webster, Sonora's little sister, joined the diving horse act when she was only fifteen years old. Arnette, who was nine years younger than Sonora, was a diving horse girl from around 1930 until 1935. Arnette also worked in other acts on the Steel Pier. She was well known for her performance with "Rex the Wonder Dog." Rex was said to "water-ski" but was actually on a sort of hydroplane. Arnette met her husband in one of the Steel Pier water shows and became Arnette Webster French.

Besides Sonora and her sister, a number of riders were hired over the years. Doc Carver's somewhat hefty daughter, Lorena, performed the stunt until 1938. In her later years, she managed the show and trained the horses.

Arnette Webster French with "Rex the Wonder Dog," 1934. The Atlantic City skyline is visible in the background. *Atlantic City Free Public Library.*

"Marie," who is seen in many postcards and photos of the act, was a rider during 1929 and 1931.

The act had to be put on hold for a while during World War II, when German U-boats lurked off the Jersey coast and blackouts were in effect. After the war, the Boardwalk lights again shone brightly, and the shows at the end of the pier resumed regularly. New high-diving horse riders were hired and trained.

Marion Hackney was the star rider from 1948 to 1961. She had previously performed in a water ballet and with the Diving Collegians on the Steel Pier. Marion had also been the assistant to a famous magician, Harry Blackstone Sr. A lifelong resident of the Atlantic City area, she worked as a swim instructor for Resorts International. The Hackney High School Girls Invitational Swim Meet in Atlantic City is named in her honor. Marion served as a deputy director of the Atlantic City Civil Defense Squad and co-chairman for disasters for the Atlantic County chapter of the Red Cross. Sadly, Marion Hackney died in 1978 at the age of forty-four after suffering from "a lengthy illness." George A. Hamid Jr., vice-president of the Steel Pier during the years when Marion was a diving horse girl, said, "She was

High-diving horse rider Marion Hackney emerges from the pool on Dimah at the Steel Pier, circa 1950s. *Atlantic City Free Public Library.*

a great performer and a great person. She might have been without my knowing it one of the first women's libbers."[89]

Three weeks before her high school graduation in 1953, a girl named Olive Gelnaw auditioned to be a diving horse rider. She persuaded her father to take her to Atlantic City so she could try out at the Steel Pier. Lorena Carver managed the show at that time and was Olive's instructor. In

her later years, Olive described her first time at the top of the platform as she mounted Dimah ("Hamid" spelled backward, as the owner of the Steel Pier at that time was entrepreneur George A. Hamid Sr.). Olive said, "I patted Dimah's neck, hoping he knew what to do next. Dimah let himself down onto the board provided for the diving position. He set his back hooves, pushed off, and I was flying with my own Pegasus!"[90] She echoed the words of other riders, saying that the horse would dive only when he was ready. "It was his decision, and his alone when to go." Olive lightheartedly called Dimah "a ham" because sometimes he'd play with the crowd by waiting and diving only when he had their full attention.

Sarah Detweiler was another one of the riders hired in the 1950s. She came up from Florida and was also trained by Lorena Carver. Dimah was her favorite horse. She went on to marry future Philadelphia Flyers announcer Gene Hart, who was performing on the Steel Pier in a different show. Sarah said that the diving horse act brought a lot to her life and that it was "totally sanctioned by the SPCA."[91]

The last high-diving horse rider was Terrie McDevitt. In the spring of 1976, while a senior at Atlantic City High School, Terrie applied for a position as an usherette at the Steel Pier. Instead, she was asked to try out as a diving horse girl. Terrie was a good swimmer but had never even been on a horse before. She made her first dive for the audition and said, "It was like landing on cement."[92] But she accepted the job and started the next day. It was hard at first, but she got the hang of it and performed twice a day, every day. She wore a helmet, a safety feature that was not used in the early days. Terrie said she was "the first diving horse girl to wear a bikini and the last."[93]

The Atlantic City of yesteryear was going through a transitional period with casinos and new hotels starting to open. The high-diving horse act ended in 1978 when Resorts International purchased the pier. The shutdown was said to be due to financial reasons. In 1993, a Florida troupe was hired to perform an act at the pier with a diving mule and other animals. There were no riders. Animal rights groups objected and put pressure on Donald Trump, whose organization controlled the pier at that time. When protesters were said "to chant 'Make Trump Jump,'" he did indeed jump to close down the attraction."[94]

In 2012, a plan to bring back a traditional high-diving horse act with riders on the Steel Pier was put into motion. Tony Catanoso, one of the pier's owners, said, "We know the diving horse is controversial, but I think people need to look at the bigger picture. A diving horse is going to be iconic. It's going to be a small piece of the development project that will bring

family entertainment back to Atlantic City."[95] Animal rights groups protested again, and online petitions were circulated; they were successful—the diving horse act did not happen.

The image of a female bareback rider on a high-diving horse is embedded in the history and nostalgia of Atlantic City. It has appeared on posters, advertisements, souvenirs and signs from the late 1920s to the present day. But the high-diving horses are not likely to perform again. The horses and other animal acts that were once on the Steel Pier—boxing cats and kangaroos, dancing bears, bicycling monkeys and water-skiing dogs—are oddities of the past.

There's a different way of thinking about entertainment in modern times. Safety and standards for the fair and ethical treatment of all animals are of great concern. Laws to protect animals are enforced more stringently. The style of entertainment has changed from the wacky stunts and vaudeville shenanigans that earlier generations watched. Now, dangerous stunts and special effects can be achieved through the use of animation and computer technology without the chance of injuries. However, some major circuses continue to include live animal acts and claim to treat their animals well, meeting all legal and moral requirements.

THE GOLDEN GLOBE AND THE THREE FEARLESS FALCONS

The diving horse act was unquestionably the best-known feature at the Steel Pier. But many other stunts and death-defying acts performed by people, not animals, also excited audiences over the years. The 1920s–'30s was the heyday for such entertainment. Although radio was gaining in popularity and broadcasts were made from the Steel Pier, visual stunts remained in demand. Average people went out to movie theaters as a weekend treat, and television wasn't in homes yet. The Atlantic City crowds hungered to see live-action thrills.

The Golden Globe, a sixteen-foot sphere perched upon the Steel Pier, contained motorcycles that would loop around and crisscross at speeds reaching seventy-five miles per hour. A young woman named Eleanore Wysocki began working in this act during the summer of 1931. The star was CeDora, who was the wife of Charles Hadfield, a Newark bike racer. Hadfield joined the act himself because it was hard to find any young men

The death-defying globe act on Atlantic City's Steel Pier featured motorcycle rider CeDora, but a girl named Eleanore was often the one performing the act. *Taken from* Atlantic City: 125 Years of Ocean Madness *by Levi and Eisenberg.*

who could ride well enough in the small area. Just six weeks before opening, Eleanore's father heard that another rider was needed and asked Hadfield if his daughter could try out. According to Eleanore, she had never even been on a bike. But her inexperience helped her to master how to ride around in loops—she didn't know any other way! She learned quickly and soon appeared in the act with CeDora, the celebrated girl inside the globe. Eleanore even alternated with CeDora, using the star's stage name instead of her own. Sometimes the act would travel to other venues, but it always returned to the pier.

Eleanore enjoyed her work, but in a letter[96] sixty years later, she reminisced about mishaps and tragedies she witnessed. She recalled the day when Sonora Carver hit the water with her eyes open and went blind as a result. Then, a terrible accident on the Steel Pier in August 1932 left Eleanore with painful memories for the rest of her life. A popular aerial act, the Three Fearless Falcons, starred Roxie and Orville LaRose, a married couple, and a young woman named Irene Berger, who was good friends with Eleanore. The falcons' high-flying routine at the end of the pier ended up in tragedy when the rigging broke at a nighttime performance. Hundreds of people watched in horror as Irene fell more than one hundred feet to her death. Roxie survived but never walked normally again. Sonora and Al Carver were close friends with them, and Sonora wrote about the terrible accident in her autobiography. Eleanore quit the Golden Globe act in 1933 to marry and raise a family. She passed away in 2008 at the age of ninety-four in New Jersey.

The daredevil performers lived on the edge, but the work was their passion. Show business provided them with a good income during the Great Depression. Unfortunately, few safety regulations were in effect during the early days of acrobatic and aerial acts, but today, better equipment helps to ensure that fewer accidents occur. Safety harnesses are often used for backup protection.

The Steel Pier's performers entertained millions of people. They attracted tourists and boosted the economy of "America's Playground" during its heyday. Entertainment in the resort city that gave us rolling chairs, Monopoly and Miss America has changed. Atlantic City, which has seen many ups and downs, is experiencing a decline again as some of the casinos closed in 2014. But new investors are buying property, and revitalization is on the horizon. The Steel Pier still exists and features many rides, arcades and food concessions, but it is a very different place. The remarkable women who performed daredevil acts on the pier are now history.

THE PHOTOGRAPHER'S DAUGHTER: VICKI GOLD LEVI

"I danced on my toes and did the hula at USO shows. I sold war bonds on the Boardwalk."

On September 16, 1941, less than three months before Pearl Harbor and America's entry into World War II, Atlantic City residents Al and Beverly Gold welcomed their first baby. The couple named their daughter Victory and called her "Vicki." The war would prove to be a nerve-wracking time along the New

Victory "Vicki" Gold selling war bonds as an adorable Junior WAC on the Atlantic City Boardwalk, circa 1944. *Photo by Al Gold; Vicki Gold Levi collection.*

Vicki Gold with her parents, official Atlantic City photographer Al Gold and Beverly Gold, in 1945. *Vicki Gold Levi collection.*

Jersey coast with the threat of possible attacks by German U-boats. In Atlantic City, soldiers trained on the beaches, and some of the posh hotels became temporary barracks. Nevertheless, life went on, and despite blackouts and rationing, tourists visited the resort city with its famous Boardwalk.

The adorable Vicki Gold blossomed as a child model and entertainer. Her mother, who had studied dance, encouraged little Vicki to be a performer, and her father exposed her to the art of photography. Al Gold was the official

photographer for Atlantic City from 1939 to 1964. Vicki would watch in awe as he developed negatives in his darkroom. His amazing photographs won numerous awards.

Soon after the war ended, the "Playground of the Nation" returned to normal with bright lights and boardwalk amusements in full swing. The famed Miss America pageant continued throughout the war. When Vicki Gold was five years old, she had the honor of being a page for Bess Myerson,

Vicki Gold as a young page with Bess Myerson, Miss America 1945. *Photo by Al Gold; Vicki Gold Levi collection.*

Miss America 1945, during her reign in 1946. The glamorous Myerson was the first and only Jewish Miss America. Wearing one-inch Cuban heels, Vicki held the long train of the beauty queen's red velvet cape. The little girl was advised to be careful and "don't trip." She didn't trip, but when she stumbled, a concerned Miss Myerson turned around to ask her if she was OK. The whole experience of that pageant was an unforgettable highlight of Vicki's life.

Vicki Gold celebrating Frank Sinatra's ten years of show business with "old blue eyes" himself, Steel Pier, 1949. The postcards on display are from his tours. *Photo by Al Gold; Vicki Gold Levi collection.*

As a child, Vicki even had her own radio show, *Views by Vicki*, on WMID, and she appeared in Tony Grant's "Stars of Tomorrow" on the world-famous Steel Pier. For Vicki, the boardwalk and the Steel Pier were like a neighborhood playground would be to most kids. Growing up in the exciting atmosphere of Atlantic City was unlike being in any other place on the Jersey Shore—or anywhere else, for that matter. It was the big time, the ultimate glitzy resort city.

Sometimes when her dad photographed celebrities, Vicki would accompany him. She got to meet great stars such as Sophie Tucker and Frank Sinatra, as well as Dean Martin and Jerry Lewis. There was never a dull moment!

Once, as a teenager, Vicki asked her dad if she could try out as a diving horse girl for the famous Steel Pier act. With a twinkle in his eye, Al Gold told her she could if she'd first try the dive without the horse. She couldn't do it!

Vicki loved Atlantic City, but in the 1960s, she decided to pursue an acting career. So she moved to New York and studied with the renowned Lee Strasberg. The multi-talented young woman also worked as a fashion sales rep for *Cosmopolitan* magazine and did publicity for the Misty Harbor raincoat company.

With her flair for entertainment and knowledge of photography gleaned from her dad, Vicki began working on books and doing photo editing. In 1979, she collaborated with Lee Eisenberg, former editor-in-chief of *Esquire* magazine, to create a delightful book, *Atlantic City: 125 Years of Ocean Madness*, which has been reprinted numerous times and is still in print today. The volume, a treasure-trove of Atlantic City history, is chock-full of photos and memorabilia.

In the 1980s, Vicki co-founded the Atlantic City Historical Museum, located on the old Garden Pier. The museum's outstanding collection of photographs and memorabilia was untouched by Superstorm Sandy in October 2012, but the building needed repairs. It reopened in 2014 and is now under the auspices of the Atlantic City Free Public Library. A project that has been near and dear to Vicki in recent years is the restoration of the magnificent pipe organs at Boardwalk Hall (formerly Convention Hall).

In 2010, Vicki was invited to be a historical consultant for HBO's *Boardwalk Empire*, the highly acclaimed fictional TV series inspired by author Nelson Johnson's book of the same name. The central character, Nucky Thompson (played by Steve Buscemi), is based on the real Atlantic City political boss of the Prohibition era, Nucky Johnson. As a child, Vicki even met the real Nucky. Vicki, along with Heather Perez of the Atlantic City Free Public Library, provided expert advice on details of vintage

A recent portrait of author and historian Vicki Gold Levi. *Courtesy of Vicki Gold Levi.*

Atlantic City for Ed McGinty, the show's chief researcher.

The photographer's daughter, Vicki Gold Levi, lives in Manhattan today. She's married, has one son and continues to write, lecture and work on a variety of projects. Over the years, Vicki has developed an interest in pre-Castro Cuba, which has similarities to Atlantic City. She published a book about vintage Cuba and donated her extensive collection of Cuban photographs and memorabilia to the Wolfsonian Museum in Miami Beach.

Vicki never gets tired of boasting about her hometown of Atlantic City and its history. She thinks New York life is great, but she's still got "sand in her shoes."

THE PRINCESS OF OCEAN CITY: GRACE KELLY

"My father had a very simple view of life: you don't get anything for nothing. Everything has to be earned, through work, persistence and honesty. My father also had a deep charm, the gift of winning our trust. He was the kind of man with whom many people dream of spending an evening."[97]

As a child, Grace Kelly spent carefree summers at Ocean City, New Jersey. She played in the sand, frolicked in the waves, rode her bike and enjoyed backyard barbecues. Grace came from the Philadelphia family of a self-made millionaire, but she could not have imagined she'd grow up to live the kind of enchanted life about which most little girls only dream. The wiry Grace with her dirty blond hair became both a movie star and a real princess.

"The Kelly family was to Ocean City and Philadelphia what the Kennedys were to Hyannis Port and Boston."[98] For many years, the Irish Catholic Kelly clan summered at Ocean City, the dry town known as "America's

greatest family resort." The Kelly family owned two houses there right across the street from each other. Their main seasonal home still stands. It's a charming Spanish Mission Revival house at 2536 Wesley Avenue that has been restored to its former beauty by recent owners. When the Kellys had it built in 1929, the neighborhood seemed far more secluded with fewer houses. Their beach house on Twenty-sixth Street at Wesley Avenue was built around 1960 and demolished in the early 2000s.

A Paramount publicity photo of Grace Kelly from the 1954 Alfred Hitchcock thriller *Rear Window*, in which she co-starred with James Stewart. *Wikimedia Commons*.

Philadelphian John Brendan "Jack" Kelly, the son of an Irish immigrant laborer, became wealthy with his masonry business. He worked his way up from simple bricklaying to major building contracts. Jack was famous not only for his money and influence but also for his athletic prowess. He switched from boxing to rowing and won gold medals as an Olympic sculler. In 1935, he made an unsuccessful mayoral run in Philadelphia. He lost by the closest margin for any Democrat in that city's history.[99] During World War II, Jack was appointed national director of physical fitness by President Roosevelt. His attractive wife, Margaret Katherine Majer, became the first woman to head the Physical Education Department at the University of Pennsylvania.[100]

Jack and Margaret had four children. Their first child, Margaret Katherine, known as "Peggy," was born in 1925, and their son, John Brendan Jr., nicknamed "Kell," came along two years later. Grace Patricia was born in 1929 and their youngest child, Elizabeth Anne, "Lizanne," in 1933. All of them have passed on.

The Kelly kids were expected to be athletic; in fact, Jack insisted on it. Kell followed in his father's footsteps and became a champion sculler. According to her sister Peggy, Grace participated in hockey and swimming to please her dad but preferred dancing and the dramatic arts. Grace wasn't

The former Kelly house in Ocean City, New Jersey, where Grace spent summers with her family. *Photo by author, 2014.*

The Kelly family sitting on a wall at their home in Ocean City, New Jersey, circa 1940s. From left to right are Jack Kelly Sr., Kell, Peggy, Margaret (Mrs. Kelly), Grace and Lizanne. *Ocean City Historical Museum.*

The Kelly family enjoying some touch football on the lawn of their Ocean City summer home, circa 1940s. Left to right are Peggy, Lizanne, Kell, Grace and Margaret (Mrs. Kelly). Jack Kelly Sr. is standing in the background. *Ocean City Historical Museum.*

shy; "she was just quiet."[101] The family had fun at the beach together and played touch football on the lawn of their Ocean City home (reminiscent of the Kennedy clan at Hyannis). With their athletic abilities, the Kelly family easily became involved with the work of the Ocean City Beach Patrol. Jack Kelly contributed generously, and Kell worked as a lifeguard.

Grace, though a quiet little girl, became more outgoing as a teenager. Numerous sources state that Grace worked as a waitress at the Chatterbox, a well-known Ocean City eatery. This story has been disputed, but she likely ate there, as it's been a popular spot since the 1920s (and is still in business today).

In a 2006 interview, Bill D'Arcy, once an Ocean City lifeguard, said that he dated Grace for two summers in the 1940s. They enjoyed the Ocean City boardwalk together, and he took her dancing at the big ballroom on Atlantic City's Steel Pier. During the off-season, they both lived in East Falls, a suburb of Philadelphia. Bill accompanied Grace to her junior prom, and she went to his senior prom, but after that the romance fizzled out.[102]

In 1947, Grace was rejected by Bennington College, apparently because of low grades in math. She then decided she'd like to study acting. Grace had two uncles who were in show business. Her father's eldest brother, Walter

Kelly, was a vaudevillian. Another elder brother, George Kelly, was a noted playwright and director. Although Grace's parents had reservations about her pursuing a theatrical career, she auditioned at the American Academy of Dramatic Arts (AADA) in Manhattan. She was accepted, thanks to her uncle George, who helped her to get in even though the quota for the class had already been met.[103] Jack Kelly said that a career in acting was "a slim cut above streetwalker."[104] At first, Grace lived at the prestigious Barbizon for Women on East Sixty-third Street while studying acting and working as a part-time model.

After finishing at the AADA, it didn't take long for Grace to land roles in numerous live television shows. She made her screen debut in the 1951 film *Fourteen Hours*. It was a small part, but soon great stars and directors took notice of her, and she rapidly rose to fame. Grace starred opposite Gary Cooper in *High Noon* (1952) and with Clark Gable in *Mogambo* (1953). Legendary director Alfred Hitchcock recognized her beauty and talent, and she subsequently starred in three great Hitchcock thrillers: *Dial M for Murder* (1953) with Ray Milland, *Rear Window* (1953) with James Stewart and *To Catch a Thief* (1955) with Cary Grant. Grace won the Academy Award for Best Actress for *The Country Girl* in 1954. She was starring in so many movies and winning so many awards that it seemed as though nothing could stop her. But then, at the age of twenty-six, she met the ruler of the tiny principality of Monaco on the French Riviera.

In the early years of her career, Grace dated many stars, and stories of her romances were all over the tabloids and movie magazines. However, she was often chaperoned by one of her sisters or by friends. While she was still single, Grace was reportedly seeing Ray Milland, her *Dial M for Murder* co-star. But Milland was married, and Jack Kelly put a stop to their affair.

A relationship developed between Grace and fashion designer Oleg Cassini. The former Russian nobleman and Grace dated for two years and were even secretly engaged. The Kelly family was not happy about Grace's romance with Cassini. After he went to Ocean City for a visit with Grace and the family, Cassini said, "Neither of her parents liked me. The weekend I spent in Ocean City was the worst of my life. I had my own room, but I had to walk through her parents' bedroom to get there."[105] Grace continued to see Cassini for a while despite her family's aversion to him, but then she broke off the engagement.

In April 1955, while attending the Cannes Film Festival, Grace was invited to take part in a photo shoot at the Palace of Monaco with the reigning sovereign, Prince Rainier III. Grace was reputedly seeing French

actor Jean-Pierre Aumont at that time, but the prince was captivated by her. He was looking for a wife who would provide him with a son to carry on the Grimaldi line. A male heir was needed or else Monaco would be returned to France as a protectorate.

Rainier traveled to the United States in December 1955 and went to visit the Kelly family. Three days later, he proposed to Grace, she accepted and the fairytale began. Their Roman Catholic wedding on April 19, 1956, was an elaborate affair held at the Palace of Monaco, although a civil ceremony also took place. Grace's wedding gown for the formal ceremony was designed by MGM's award-winning Helen Rose.[106]

Princess Grace and Prince Rainier had three children. Caroline was born in 1957, less than a year after her parents' wedding. Their son, Albert, was born in 1958 and Stephanie in 1965. The princess mom maintained a busy schedule of royal duties and charity work. She never made another movie, although she had offers to do so. Her last film was *High Society* with Frank Sinatra and Bing Crosby, released the same year as her marriage.

Despite all her duties and protocols as a princess, Grace never neglected her American family and continued to spend vacations at Ocean City. For a few weeks in the summer, the Rainier family would visit the Jersey Shore so the children could enjoy the beach with their American cousins. The royal visit was usually timed so that they'd be in Ocean City for the Kelly family's annual Labor Day barbecue. Not surprisingly, when word got out about the royal visitors, tourists would scramble to get a peek at them. But the locals and the Kelly neighbors were said to show great respect for the privacy of Grace and her family.[107]

On September 13, 1982, Princess Grace insisted on driving herself and her seventeen-year-old daughter Stephanie to Monaco from Roc Agel, their French country home. She did not want her chauffeur to drive, supposedly because there was not enough room in the car, as Princess Grace had spread clothing out across the back seat. On the twisting and treacherous hilly road, Grace apparently suffered a stroke and failed to maneuver a hairpin turn. Her car plummeted down a steep embankment. Grace never regained consciousness and died on September 14, 1982, at the age of fifty-two. Stephanie survived with minor injuries but suffered deep emotional scars. The accident, which stirred up nasty rumors and controversies, was a terrible shock and a severe blow to the families, to Monaco and to her fans around the world. Grace is buried in Monaco Cathedral, and her husband, Prince Rainier III, who died in 2005 at the age of eighty-one, is interred next to her. Albert, the only son of

Princess Grace and Prince Rainier, is currently the reigning monarch of the principality of Monaco.

A retrospective exhibit, "From Philadelphia to Monaco: Grace Kelly Beyond the Icon," opened in October 2013 and lasted for three months at the James A. Michener Museum in Doylestown, Pennsylvania. Princess Grace's original wedding gown, which now belongs to the Philadelphia Museum of Art, was too fragile and light sensitive to be displayed, but other items from the wedding were on view.

A delightful ongoing exhibit about Grace Kelly can be seen year-round at the Ocean City Historical Museum (www.ocnjmuseum.org). A display case contains a collection of Kelly family photos and memorabilia, including vintage "Kelly for Brickwork" playing cards. Movie posters and photographs from Grace's Hollywood career are displayed on a wall. Perhaps the most eye-catching item of all is an exquisite replica of her wedding gown donated to the museum by a woman from Maryland who had Grace's dress duplicated for her own wedding.[108] The spirit of Grace, who once built sandcastles at Ocean City, lives on at the New Jersey Shore.

The remarkable Grace Kelly is remembered as a larger-than-life legend along with Jackie Kennedy, Marilyn Monroe and Princess Diana. A biopic film, *Grace of Monaco*, starring Nicole Kidman as Grace, was released in 2014 to mixed reviews and controversy. There have been countless books, articles and films made about Grace over the years. The Princess Grace Foundation–USA (www.pgfusa.com) provides assistance in the form of scholarships and grants "for emerging theater, dance and film artists."

THE "RUMBLE DOLL": PATTI SCIALFA

"I remember going to the Long Branch boardwalk when I was a little girl and then the Asbury Park boardwalk when I was a teenager. There was always a feeling of low down magic to it. The carny at night, the air was thick with all these intoxicating scents; fat grease from French fries, peanuts roasting at the Mr. Peanut stand and the salty, humid air drifting in from the Atlantic. Everything was lit up. It was beautiful and romantic. As a teenager, you'd go at night, walk the boards and meet all your friends. You felt free. It just had this air of possibility."

The vivacious redheaded rocker Patti Scialfa, who happens to be Mrs. Bruce Springsteen, started performing long before she met "The Boss." Patti is a

superstar in her own right. As a teenager, she began singing and writing songs. She became the first female member of the legendary E Street Band in 1984. Married to Springsteen since 1991, Patti is a devoted wife and mother to their three children.

A Jersey girl who was born in Long Branch in 1953, Patti spent her early childhood in Oakhurst and moved to Deal when she was in sixth grade.[109] She graduated from Asbury Park High School in 1971. Patti's father, Joseph Scialfa, was of Sicilian ancestry, and her mother, Vivian (née Morris), was born in Belfast. Joseph owned a television store in Monmouth County for years but later became a successful real estate developer. Patti was their middle child, and she has half siblings from her father's second marriage.[110] When she was a preschooler, Patti would sit down at the piano with her grandfather, who was once a songwriter on the London vaudeville circuit, writing songs for the famous Marie Lloyd. She first began to love music as a result of these sessions.[111]

After high school, Patti attended the University of Miami's jazz conservatory at the Frost School of Music. She later transferred to New York University, where she received a degree in music.[112] In a *Lear's* magazine interview, Patti said "that she had little talent for anything but music and that she attended college as a way to further her ambitions as a performer while also satisfying her parents' expectations."

In the late '70s, Patti accepted whatever music-related jobs she could get and even took to busking on the streets of Manhattan. She got her professional start in the music industry working as a backup singer and toured with David Sancious and his band Tone, which he started after leaving the E Street Band, and Southside Johnny and the Asbury Jukes.

In New York, Patti also had her own band, performing her original music with Soozie Tyrell and Lisa Lowell at clubs such as Kenny's Castaways, The Bitter End/Other End and Folk City, trying to get a record contract. She would come down to the shore to visit her family on weekends and sit in with the Bobby Bandiera band Cats on a Smooth Surface at the Stone Pony in Asbury Park. It was there that she was singing the old 1963 Exciter's hit "Tell Him" when a rising rock star named Bruce Springsteen, who was just finishing his *Born in the U.S.A.* record, introduced himself and they became friends. Rumor has it that he auditioned her in the 1970s but didn't hire her because he thought she was "too young." Then, in 1984, he signed her on as the E Street Band's only female member three days before the first concert in St. Paul, Minnesota. She quickly packed her bags and joined the Born in the U.S.A. tour.

It was a big change to have a woman in the band. At first, it was Patti's job to be sure that "someone's gonna hit that note, every night."[113] Besides her musical ability, Patti's presence provided a new dynamic for the previously all-male band. "The male/female interplay that was possible with Patti's presence became a key part of the Tunnel of Love tour in 1988 with Patti in a featured role at center stage with Bruce on 'Tougher Than the Rest,' 'Tunnel of Love,' and 'One Step Up,' among others."[114]

A 1993 publicity photo for Patti Scialfa's solo album *Rumble Doll* (Columbia Records). *Photo by Neal Preston; courtesy of Jon Landau Management and Columbia Records.*

Bruce and Patti became romantically involved in the late 1980s, and on June 8, 1991, they were married in a private ceremony in Beverly Hills. They have three children: Evan, born in 1990; Jessica, born at the end of 1991; and their youngest, Sam, born in 1993.

Patti has continued to work with the E Street Band and has recorded three solo albums for Columbia Records. Her first album, *Rumble Doll* (1993), was a big success. Patti composed eleven of the twelve tracks. The title song reflects the feelings of a young woman discovering love and has such memorable lines as "Come protect this china heart." In 2004, her nostalgic work *23rd Street Lullaby* was well received, and in 2007, she had a hit album once again with *Play It as It Lays*. Patti wrote all of the songs on the second two albums and is presently at work on her fourth record.

During this time, Patti also performed on several hit recordings, including Emmy Lou Harris's "Tragedy," the Rolling Stones' "One Hit to the Body," Keith Richards's "Talk Is Cheap" and Blackie and the Rodeo Kings' "Shelter Me." Emmy Lou Harris recorded two of Patti's songs: "Valerie" with Linda Ronstadt and "Spanish Dancer" with Rodney Crowell.

Although they own several homes, Patti and Bruce chose to have their children grow up in the area where they were both born and raised, Monmouth County, New Jersey. They own a horse farm in Colts Neck and a house in Rumson, as well as homes in Florida and Los Angeles.

The Springsteen kids have grown up—it seems like kids always grow so fast! Their famous parents have done their best to keep them out of the limelight and to spend quality time with them. Patti and Bruce's younger son Sam became a firefighter in January 2014. He joined the Colts Neck Fire Department after passing a rigorous course at the Monmouth County Fire Academy.[115] His proud mom posted a photo of him in his firefighting gear on her Instagram page. Their elder son, Evan, graduated from Boston College in 2013, works in the music industry and is a musician. Their daughter, Jessica, who graduated from Duke University, is a champion equestrienne. Mr. and Mrs. Springsteen have attended horse shows in the United States and in Europe to watch their talented daughter ride.

The fiery redheaded rock-and-roll mama Patti Scialfa Springsteen takes great pride in her children's accomplishments. Now in her early sixties, she looks great and is still married to "The Boss." Patti is a dynamic woman with a remarkable history as a musician and a true Jersey girl.

A FORTUNETELLER: MADAM MARIE

"Did you hear the cops finally busted Madam Marie for tellin' fortunes better than they do..."[116]

Although the lyrics of a 1973 song recorded by Bruce Springsteen hurled Madam Marie into the limelight, she was never "busted" by the police. Her name was Marie Castello, and she operated a legitimate business on the Asbury Park Boardwalk for over seventy years. The psychic adviser began giving readings in 1932 during the Great Depression. It was a time when people desperately needed to hear some encouraging words about the future. Of course, whatever the customers were told remained private.

The boardwalk at Asbury Park was a far different place in the days when Marie first opened her booth. People dressed up in their Sunday best to go for a stroll—no T-shirts or cutoff jeans in those days. Bathing suits weren't allowed on the boardwalk, and shoes were required. Her customers were ladies in stylish dresses and hats and men in three-piece suits and fedoras. According to Madam Marie, she even had customers who wore formal clothes, including evening gowns and tuxedos.[117] It might have been the Depression, but people didn't skimp on getting dressed to the nines.

Madam Marie's little fortunetelling hut on the boardwalk, the Temple of Knowledge, has become a landmark. It's an icon of historic Asbury Park along with the smiling face of "Tillie," the old carousel, Convention Hall and the Stone Pony. The sidewall of Madam Marie's establishment displays a prominent single eye, a most intriguing symbol for the business. The hut's sign has been repainted and the logo altered over the years, but a mystical eye has always remained.

In May 2008, well-known sports and feature writer Bill Handleman conducted a rare interview of Marie Castello for his *Asbury Park Press* column. This proved to be an in-depth and personal account of the fortuneteller's life. Marie was born in Neptune City in 1915 and said that her father was Irish and worked making things such as "pots, hand fans, and baskets."[118] Her mother came from Canada, and her mother's father was from Australia. When she was very young, Marie married Walter Castello, a car salesman. They had four children and fourteen grandchildren. Their marriage lasted for over seventy years until his death in the late 1990s.

Handleman wrote his column about Marie soon after he had been diagnosed with cancer, which would take his life two years later. When he visited Marie Castello at her home for the interview, she was ninety-two

Madam Marie's "Temple of Knowledge" on the Asbury Park Boardwalk, 2014. *Photo by author*.

years old. Marie told Handleman's fortune, and it might have been the last reading she did.

"In the newspaper business," Handleman wrote, "you take nothing on faith, rule number one. Events must make sense. Stories must be confirmed. Empirical evidence is mandatory. In the newspaper business, you become a skeptic at an early age. Yet, there are still things that throw you, things that haunt you."[119]

Madam Marie wanted to know if there was a health problem in Handleman's family and then asked if he was the one who had the problem. When he said yes, she told him not to worry. She said everything would be fine. "Months later, when Marie's prediction proved undeniably inaccurate, Handleman did what he always did when presented by life's ironies and twisted humor. He thought about it and then he laughed like hell."[120] Bill Handleman died two years after the interview, in 2010.

Marie told Handleman how celebrities often stopped in to have her do a reading. She allegedly met the Rolling Stones, Elton John, Judy Garland, Diane Keaton, Perry Como, Woody Allen and others. She also said that kids who worked on the boardwalk in the 1960s all knew her and that "some kid named Springsteen" would hang around the Temple of Knowledge. Marie

claimed that he once said, "All I've got is 50 cents," and she told him, "You don't have to give me your 50 cents."[121] She supposedly predicted that he'd be famous, but she probably said that to all the boys—or so Springsteen said.

In the late 1960s and into the 1970s, Asbury Park suffered a terrible decline, and Madam Marie didn't like to talk about those years. She preferred to remember the good times of previous decades. But Madam Marie had hope for the future, for a bright future. The opening paragraph of Handleman's column goes like this: "Someday soon, she says, Asbury Park will recapture…a glory. Take her word for it. She knows. She sees the future. She has the gift." Madam Marie was on target with this prediction. In recent years, Asbury Park has made a comeback with restaurants, stores, theaters and more improvements all the time. It's a far trendier place than it was in the old days, but it's thriving. Gone are the days of honky-tonk entertainment, pony rides, greasy foods and "guess-your-weight" booths.

Marie Castello died peacefully at the age of ninety-three on June 27, 2008, less than two months after the interview with Bill Handleman. The American flag by Asbury Park's Convention Hall was flown at half-mast in her honor.[122] Members of her family now carry on her legendary business. They continue to give readings at the Temple of Knowledge on the Asbury Park Boardwalk and at several additional locations.

After her death, Bruce Springsteen paid tribute to Madam Marie on his official website:

> *Back in the day when I was a fixture on the Asbury Park boardwalk, I'd often stop and talk to Madam Marie as she sat on her folding chair outside the Temple of Knowledge. I'd sit across from her on the metal guard rail bordering the beach and watch as she led the day trippers into the small back room, where she would unlock a few of the mysteries of their future. She always told me mine looked pretty good—she was right. The world has lost enough mystery as it is—we need our fortunetellers. We send our condolences out to her family who've carried on her tradition. Over here on E Street, we will miss her.[123]*

Chapter 6

INNOVATORS AND LEADERS

A STYLISH ENTREPRENEUR: SARA SPENCER WASHINGTON

"As long as there are women in the world, there will be beauty establishments."

From small-town southern girl to chic New Jersey resort city millionaire, Sara Spencer Washington's inspiring story is one of hard work and determination. She grew up during a time when it was hard for a woman to get ahead and even harder for an African American woman. Born in 1889 to a lower middle-class family in Virginia, Sara possessed the drive to succeed and never gave up on her dreams. At first, she worked as a dressmaker, but she had aspirations of becoming an entrepreneur. Sara attended Norfolk Mission College and later received a degree in business administration from Northwestern University. The bright young woman also studied at Columbia University.

Sara and her ailing mother relocated to Atlantic City in 1911. Her mother's doctors believed that the salt air would be therapeutic and the change of scene beneficial. The down side of the move was that the only work Sara could find in Atlantic City was as a domestic. She craved something that would be more creative, challenging and lucrative. Utilizing her excellent entrepreneurial skills, the attractive Sara soon opened a beauty parlor on Arctic Avenue. At this shop, she could service the needs of black women, who were not welcome at Atlantic City's upscale hotel salons that pampered only white visitors.

Atlantic City's elegant cosmetics entrepreneur "Madam" Sara Spencer Washington in the 1930s. *Atlantic City Free Public Library.*

To understand what Sara was up against, it's necessary to know something about the difficulties that African Americans faced in Atlantic City. Although much of the city's population was black, they were not accepted at local beaches. The "Playground of the Nation" did not embrace everyone. From the early days of the resort until more recent years, there was widespread informal segregation. Hotel owners complained if they spotted black bathers on beaches in front of their establishments where they could be seen by the guests. Few African Americans were seen on the Boardwalk, except for workers pushing rolling chairs occupied by smug white vacationers and rowdy conventioneers. Although there were no laws to keep them off the beaches, people of color were "socially restricted" and made to feel uncomfortable. Regardless, some African Americans did go to those beaches, but the Missouri Avenue beach was the only one acceptable for black visitors in the early years. Locals from the black community followed them and, in the 1950s, nicknamed it "Chicken Bone Beach." The beach was recognized as a historic site by the Atlantic City Council in 1997.

In about 1916, Sara married Isaac Washington, but they separated in 1919. Much later, in 1944, Sara married Shumpert Logan but retained the surname Washington for business and professional use. Sara did not have children of her own, but she adopted a young cousin, Joan Cross, as her daughter.

Sara took her business a step further when she began teaching hairdressing and developing a line of beauty products. In 1920, she opened the Apex News & Hair Company to fill the need for products designed especially for African Americans. She had a beauty school, as

Madam Sara Spencer Washington (standing) with her mother and daughter, Joan Cross Washington, circa 1930s. *Photo courtesy of Royston Scott.*

well as a laboratory in Atlantic City for the research and development of her Apex line and maintained an office in New York City. She acquired patents for hair oils and scalp creams to improve hair-straightening methods. More than forty-five thousand agents were said to be selling Washington's products, which had expanded to include beauty creams, cosmetics and perfumes.[124]

Only a handful of businesses specializing in products specifically for African Americans existed in the United States during the late nineteenth and early twentieth centuries. The most famous female black cosmetics entrepreneur of all was Madam C.J. Walker (1867–1919), who was considered to be the first black female self-made millionaire in the United States.

During the Roaring Twenties and into the lean years of the Great Depression, Sara's business boomed. Her beauty schools were turning out as many as four thousand graduates a year by the mid-1930s.[125] The Depression provided an impetus for black women to receive career training and establish their own salons whenever possible. The title "Madam" was one of respect and admiration in the early years of the twentieth century, and it was Sara's workers who first gave her this title. Madam Sara encouraged black women to be self-employed, and hairdressing was a respectable and profitable business. "Now is the time to plan your future by learning a depression-proof business" was Madame Sara's slogan. She proved that African American women could prosper and did not have to work as domestics or hotel maids.

Starting with a one-room beauty shop, her company grew to be the most significant black-owned business in New Jersey. Madame Sara was honored for her outstanding achievements at the 1939 New York World's Fair. Her companies around that time included the Apex News and Hair Company, the Apex Publishing Company, Apex Laboratories, the Apex Drug Company and Apex Schools of Beauty Culture. Atlantic City was the site of her first school, but others soon cropped up in Philadelphia; Chicago; Newark, New Jersey; Brooklyn; Auburn and Butler, New York; Atlanta; Richmond; and Washington, D.C. There were even Apex schools in Johannesburg, South Africa, and some in the Caribbean.[126] "An estimated thirty-five thousand individuals throughout the world were dependent upon the sales of its (Apex) products and its method of 'Scientific Beauty Culture.'"[127]

Besides running her profitable beauty empire, the dynamic Madam Sara started a nursing home called Apex Rest to house elderly residents of Atlantic City. She founded a golf course in Galloway Township, the Apex Golf and Country Club (today the Pomona Golf and Country Club), after she was allegedly denied membership in a local golf club. Her new club was open to all races.

Perhaps Madam Sara's most community-minded contribution during the Great Depression was to help disadvantaged locals obtain coal for heating their homes. Stories are told of Madam Sara buying "carloads" of coal and leaving them on the streets for the people who needed it. She also had coupons for coal dropped from airplanes over needy areas of the city.[128]

In 1944, in nearby Brigantine City, Madam Sara purchased a hotel from a religious leader, Father Divine. It became known for having the first integrated beachfront in the Atlantic City area. The Hotel Brigantine is now the Legacy Vacation Resorts Brigantine Beach. The site is listed on the

Madam Sara at the Apex Golf Club, which she owned, in Galloway Township, circa 1950. With her are two illustrious Atlantic County figures, New Jersey state senator and political "boss" Frank S. "Hap" Farley (left) and James "Sonny" Fraser, amateur golf champion and politician. *Atlantic City Free Public Library*.

New Jersey Women's Heritage Trail and is the only building that survives completely intact from those of Madam Sara's enterprises.

Madam Sara campaigned for civil rights with passion and commitment. Captain Starn's, a popular Atlantic City restaurant and tourist attraction, was ostensibly refusing service to people of color. On December 14, 1945, the headline of the *Telegram* read, "Madam Washington Kills Race Ban at Starn's Restaurant." Sara Spencer Washington led a long legal battle to put pressure on the restaurant to change its policies. She was successful, and it was a step forward in the struggle for equality.

A situation that concerned Madam Sara was the obvious discrimination occurring during one of Atlantic City's best-known events, the Boardwalk Easter Parade. The white judges were paying no attention to attractive black contestants despite the fact that they looked terrific in their Easter finery. Upscale ladies who wore stylish dresses, elegant Easter bonnets and fur stoles; men who sported sophisticated suits and hats; and beautifully dressed

children were all being ignored by the judges. Sara was outraged by the unfairness in the celebrated event, and she spearheaded a separate parade for African Americans. She was a sponsor for a black Easter parade in 1946 that paved the way for an integrated event.

In 1947, Sara suffered a stroke that left her unable to function as she had before, but she continued to aid the local African American community in Atlantic City. Never one to give up, she worked to regain her speech and was able to abandon the cane she had been forced to use.

Sara Spencer Washington died in 1953 at age seventy-two. The Apex schools were sold to their directors before she died. Her adopted daughter, Joan Cross Washington, inherited the controlling interest of the company. Following in her mother's footsteps, Joan, who was a well-known black debutante, proved to be an exceptionally capable businesswoman. As president of Apex, she became the beautiful face of the company. Joan modeled and appeared in vintage magazine ads, including one for Philip Morris in the late 1950s. The ad featured her as herself, a famous businesswoman smoking a cigarette. It is especially notable for an African American woman to be featured in advertisements during the 1950s. Joan spoke at such famous venues as New York's Waldorf Astoria and said that "Apex was one of the few businesses to make it through the Depression."[129] Inspired by her mother, Joan ran the business until its demise in the early 1960s.

The remarkable Madam Sara Spencer Washington goes down in the annals of women's history as an intelligent and talented woman who was way ahead of her time.

THE CULINARY WITCH: KARYN JARMER

"Living the life you love…"

Watch carefully—you won't believe your eyes! She's a food magician with an amazing number of tricks up her sleeve. This contemporary Jersey Shore enchantress runs a unique and booming catering business, café and market. The dishes she conjures up are the result of hard work mixed with a dash of ingenuity and a dollop of fun.

Of course, Karyn Jarmer isn't a real witch; she's a chef and business owner with roots at the Jersey Shore. Born in Neptune in 1965, she grew up in Shark River Hills and watched her mom preparing wholesome and

Karyn Jarmer, chef and caterer, is the attractive "head witch" who owns My Kitchen Witch in Monmouth Beach. *Photo by author, 2014.*

delicious food. Karyn spent her summers enjoying the surf at Bradley Beach and other nearby seashore towns. As a teenager, she worked at Schneider's Restaurant in Avon, where her passion for the food industry blossomed. Karyn got a taste of what it's like to waitress, hostess and cook. She "loved the business," and working by the ocean made it especially enjoyable.

After graduating from high school in 1983, Karyn headed for the city. Her first job in the Big Apple was at the Fulton Fish Market. This was "her college," as she learned on the job. She shucked clams and did menial tasks but worked her way up quickly to become the manager of a South Street Seaport café. In the early 1990s, her magical career would soar, but not on a broomstick at first. It took stamina and diligence to establish her place in the competitive world of catering. She operated Bedrock Catering and began preparing meals to feed the cast and crew of well-known television shows. She catered for soap operas, and many of her jobs were for popular talk shows, including those of Sally Jesse Raphael, Maury Povich, Regis Philbin and Rosie O'Donnell.

Catering the *Rosie* show presented some challenges for Karyn Jarmer. The stress level was high, and she jokes that she "thinks she gained fifty pounds" during those years. A request that truly tested Karyn's ingenuity came when Madonna was a guest on the program. Madonna had specific requirements, as she was following a strict vegan diet. Karyn Jarmer managed to pull it all together in very short amount of time, and the show people were amazed at how she could create such great food at the drop of a hat. Jarmer became known as a good "witch" who could perform culinary magic. It was really tough work not performed by simply waving a wand. But she's a determined woman who knows she can do most anything if she puts her mind to it.

Karyn Jarmer had established a thriving business in the city, but after the terrorist attacks of September 11, 2001, she decided to move back to the New Jersey Shore. Her fifth-floor walkup on Manhattan's upper West Side was lonely, and she longed for the beach and her home turf. In 2005, she opened a café on Beach Road in Monmouth Beach and named it My Kitchen Witch. Since she was still within commuting distance, she was able to continue catering for New York television shows, films and other events.

The café is decorated with all sorts of fun, witchy memorabilia that patrons have presented to Karyn. Music from the 1940s is heard in the background because "The Witch" says it reminds her of her dear grandmother. The menu features fresh, homemade comfort food. The selections, many of them with clever names, include such healthy choices as "Organic Oz Salad." There are numerous "sandwitches" to choose from, and "Eggs Benewitch" is a favorite.

Karyn customizes the catering menus for her clients. The list of television shows she's catered is impressive: *Celebrity Apprentice*, *Project Runway*, *The Colbert Report*, *Worst Cooks in America* and many more. She has also provided food for big occasions such as the Rainforest Fundraiser with Elton John at Carnegie Hall in 2012.

According to The Witch, her most "awesome" assignment was in 2008 during Pope Benedict XVI's historic visit to the United States. She catered the huge event in honor of his departure, which was held at John F. Kennedy Airport in the famous old Hangar 19 (from Idlewild days) and hosted by Dick Cheney. Many dignitaries and VIPs attended, including Bill and Hillary Clinton. It was a daunting task, but Karyn pulled it off, proving her magical ability once again.

Karyn Jarmer's work is stressful, but vigorous exercise helps to keep her going both physically and mentally. She doesn't merely work out; she competes

in triathlons and manages to find time to train for them despite her incredibly busy schedule. Naturally, her own diet is healthy, and her personal favorite cuisines are Thai and vegan.

Disaster struck My Kitchen Witch in October 2012. Karyn was devastated by the wrath of Superstorm Sandy. "My business was 100% destroyed," she said. The Monmouth Beach café and market were flooded and shut down. Her house was also damaged, but her beloved pets were saved. The cleanup and reconstruction couldn't be accomplished by waving a wand; it took hard work and patience. Then, the magical moment happened—the café and market reopened in April 2013.

The Witch continues to feed the casts and crews of major television and film productions. Her fleet of seven vehicles, most of them operated by female employees, delivers delicious meals seven days a week—or as she likes to say, "The witch staff flies on their brooms" to deliver fresh food!

You won't see the witches of Macbeth stirring up a

Carrot and Ginger Soup

The recipe for a delicious "potion" (soup!) from A Witch in the Kitchen *by Karyn Jarmer*

2 cups onions, chopped
2 tablespoons extra-virgin olive oil
5 cups vegetable broth
1 cup water
2 cups carrots, peeled and diced
5 tablespoons fresh ginger, grated
1 teaspoon cinnamon
1 teaspoon coriander
cayenne pepper
salt
ground black pepper
½ cup fresh cilantro, chopped

1. In a large stockpot, sauté onions in oil until softened—about 10 minutes.
2. Add the vegetable broth, water, carrots and 3 tablespoons ginger and bring to a boil.
3. Reduce heat and simmer, covered, for about 30 minutes, or until carrots become tender.
4. Transfer to a blender and add remaining 2 tablespoons ginger, plus cinnamon and coriander. Blend until completely smooth. Add a little more water if a thinner consistency is desired.
5. Season with cayenne, salt and pepper to taste.
6. Garnish with cilantro before serving.

For more information about Karyn's cookbook and *My Kitchen Witch*, visit her website at www.mykitchenwitch.com.

In the kitchen of My Kitchen Witch, her Monmouth Beach café, Karyn Jarmer whips up some magical delights. *Photo by author, 2014.*

pot of stew at My Kitchen Witch. The only "toil and trouble" you'll find is in the name of a menu item, "The Toil and Trouble Omelet." No old hags here, just a pleasant and cozy place with a fine staff and an owner who is a remarkable female entrepreneur.

THE "BIG GIRL": DORIS BRADWAY

"I want to do what's best for the greatest little city in the world."[130]

A large and imposing woman, Doris Bradway knew how to take command of most any situation. A champion for the growing number of women in Depression-era politics, Bradway was the mayor of the city of Wildwood from 1933 to 1938, from the end of Prohibition and during the Great Depression.

Doris Bradway, the controversial mayor of Wildwood in the 1930s. *George F. Boyer Museum, Wildwood Historical Society.*

Born in Elizabeth, New Jersey, in 1895, Doris was the daughter of a well-respected Princeton professor, Howard Crosby Warren, who chaired the university's psychology department. Around 1920, she moved to Wildwood with her husband, Edwin T. Bradway, and their two young children. With Noble Bright, the son of W.H. Bright, the Bradways established a tin-roofing and sheet metal company. It didn't take long before Doris became involved in the civic affairs of the Five Mile Beach area. Doris Bradway campaigned diligently for William H. Bright, a Holly Beach real estate broker, who served as a county sheriff and was a state senator for three consecutive terms from 1918 to 1927.

In 1932, a tragic event launched Bradway's political career. When Commissioner Kenneth K. Kirby was killed in an automobile accident, William H. Bright, mayor of Wildwood at that time, appointed Bradway to fill Kirby's position. Only a few months later, Bright died suddenly, and Doris W. Bradway became Wildwood's mayor. She is often said to be New Jersey's first female mayor, but there were others who might have preceded her.

Politics in Wildwood has a colorful and checkered history. In the presidential election of 1932, the majority of Cape May County voters favored Republican incumbent Herbert Hoover; however, most people across the depressed nation wanted a change, and Franklin Delano Roosevelt was elected. Doris Bradway held office in Wildwood as a Republican but campaigned for Roosevelt.

Doris W. Bradway, the "Big Girl" (though it might sound derogatory, it was likely a term of endearment), won the favor of various ethnic and

women's groups. She listened to the needs of African Americans and Italian Americans. In 1934, Bradway, along with Josephine Bright and Grace McGonigle, organized a group exclusively for women called the Bradway Republican Club.[131]

Mayor Bradway, famous for her outspoken remarks, made the newspapers frequently, and of course, reporters couldn't get enough of her. She didn't speak much about her personal life, but Bradway got tired of the public and the press calling her the "Big Girl." She was wearing a size fifty-two and decided to go on a diet. In 1936, she lost 102 pounds; her weight reportedly plummeted from 267 pounds to 165.

Doris's determination to lose weight reflected the way she did everything—with conviction and confidence. Her dramatic weight loss, which today might compare with the popularity of television's *The Biggest Loser*, was a hot topic in the newspapers. The media even published menus from her diet. A typical meal for Doris consisted of pineapple juice, sliced tomatoes, chicken, coleslaw and peas. She cut down on sugar and paid attention to portion control. After losing weight, she declared, "I can even cross my legs!" Photos of her riding a bicycle on the Wildwood Boardwalk showed her fans that it wasn't all about diet; exercise was also needed.[132]

A May 17, 1937 *Time* magazine article reported that "the New Jersey Assembly appropriated $35,000 for an investigation of the mayor of Wildwood" and that Wildwood's Independent Taxpayers' League would petition to demand the mayor's resignation. The charges of the investigation were for not just one questionable incident but many. The former "Big Girl's" feathers weren't even ruffled; she was confident she'd get through it all. *Time* called her dramatic weight loss the "most diverting of all her stunts" because the citizens applauded her for sticking with her incredibly successful diet.

The mayor also demonstrated her strength to the men of Wildwood at a wrestling match in the Municipal Auditorium. "The audience became displeased with Wrestler Joe Savoldi for the tactics he was using to subdue his opponent, one Stanley Sokolis, and heartily approved when Mayor Bradway grabbed a plank, climbed into the ring and brought it down on Wrestler Savoldi's skull."[133]

Bradway never left the Republican Party, but her career suffered from the fact that she often sympathized with Democrats and spoke out against Republicans. She became involved in a heated dispute with amusement entrepreneur William C. Hunt, who was a local Republican leader. Mayor Bradway shut down his theaters on Sundays, and Hunt subsequently sued Bradway for $50,000.

"Mayor Doris Bradway, of Wildwood, who now weighs 165 pounds is showing Mrs. Patrick Shortt, left, wife of the resort's postmaster how to lose weight by riding a bicycle on the Boardwalk. The Mayor by diet and exercise cut her weight from 267 pounds." Taken from a 1936 news clipping. *George F. Boyer Museum, Wildwood Historical Society.*

Mayor Bradway was always involved in one controversy or another. In 1935, she and her police chief went to trial on charges of "malfeasance" for allowing illegal slot machines to be operated in Wildwood. Bradway was acquitted, but the police chief was convicted, as he allegedly ignored the slots before Bradway took over the mayoral office.

Despite all of her bravado, Doris Bradway paved the way for women in local politics to become respected leaders during the 1930s. Some capable women held posts in the Cape May County government during the New Deal decade, and women served on several boards of education, effectively saving their public schools from financial ruin. Female African American leaders emerged during this time, and women organized Democratic clubs, although those backing Roosevelt's policies did not have widespread acceptance. Cape

May County remained predominately Republican and leery of the New Deal programs for fear of too much federal government control.[134]

Local Wildwood physician and civic leader Dr. Harry Hornstine, a musician by avocation, composed a song in honor of Doris W. Bradway. It's certainly not remembered as a big hit of the Depression era, though. The title of the sheet music was simply "Wildwood," and it never even came close to the popularity of Bobby Rydell's 1963 hit "Wildwood Days."[135]

Frank Hague, mayor and well-known Democratic political boss of Jersey City, considered Doris to be both his ally and his enemy. He held meetings with her and even invited her to a political rally in which they shared a private box with FDR and Eleanor. Eventually, however, Doris decided not to make any deals with Hague, and he did everything he could to bring her down.[136]

In the 1938 Wildwood mayoral election, Doris Bradway was recalled out of office, and she never served as mayor again. Since her name faded from the newspapers with the end of her political career, little is known about her later years. Though she led a quieter life, she did keep a hand in civic affairs. She died in 1982 and is remembered for her bold and remarkable career.

Great was the charm and appeal which grandmother exuded. You could either adore her with every ounce of strength or despise her deliciously—there was no place for indecision.[137]
—*E. Warren Bradway*

AN OCEAN ADVOCATE: CINDY ZIPF

"Treasures of the sea enrich us all beyond wealth."

An adventurous little girl named Cindy loved to play in the tide pools and go seining near her family's home in the Rumson–Sea Bright area. Born in 1959, Cindy Zipf dreamed of becoming a marine biologist. Her admiration of the sea and its creatures, both great and small, has been her passion ever since she can remember. She grew up to become a dynamic activist and is now on a relentless mission to stop pollution at the New Jersey Shore. She is the executive director of Clean Ocean Action (COA), a position she's held since 1984.

Cindy's father was an avid recreational fisherman with respect for his catch, whether eating it or releasing it. He started a fishing club, and when

Cindy was about eleven or twelve years old, she opened up her own little bait business. She sold green crabs to her father's fishing buddies for twenty-five cents a pop. While growing up, Cindy's favorite television show was *The Undersea World of Jacques Cousteau*. She also watched *Flipper* during a time when the public, in general, was not yet aware of the plight that dolphins were facing. For Cindy, and for many others, that would soon change.

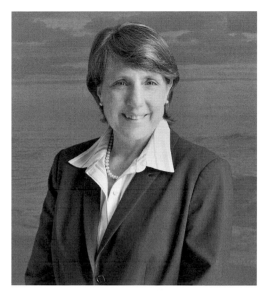

Cindy Zipf, executive director of Clean Ocean Action. *Photo by Danny Sanchez; courtesy of Clean Ocean Action.*

Cindy Zipf received a BA from the University of Rhode Island, majoring in geography and marine affairs with a special emphasis in marine science. One of Cindy's heroes is marine biologist and author Rachel Carson (1907–1964), who wrote such provocative best sellers as *The Silent Spring* and other works that spearheaded the environmental movement and gave inspiration to grassroots conservationist groups. In *The Silent Spring*, Carson wrote, "Those who contemplate the beauty of the earth find reserves of strength that will endure as long as life lasts. There is something infinitely healing in the repeated refrains of nature—the assurance that dawn comes after night, and spring after winter."

With the goal of becoming a marine scientist, Zipf took a position as an intern at the James J. Howard Marine Sciences Laboratory. While monitoring marine animals, she observed some of them trying to jump out of the tank! They were "experiencing great distress" in reaction to pollutants. Zipf wrote to Dery Bennett of the American Littoral Society, a renowned leader in the field of conservation, about a job with his organization. He interviewed her, and she was hired as an intern in 1982–83.

During the 1970s–'80s, the beaches along the New Jersey coast were littered with disgusting garbage, including medical waste; dumping from ships was rampant; and red tides were occurring all too frequently. The once-idyllic waters and beaches of New Jersey were getting a bad reputation,

which led to a decline in tourism. The seafood industry suffered also, and the economy of the area was in deep trouble.

In July 1976, a terrible offshore fish kill occurred off the Jersey coast. While America's bicentennial was being celebrated, a massive three thousand square miles of sea floor was suffocating from pollution and littered with millions of dead fish and other marine life. Cindy Zipf was still in high school at that time and learned about it while she was an intern with the American Littoral Society in 1982. Ocean dumping was still going strong, and this was when Cindy became an advocate for the sea.

Something had to be done. Awareness is always a good tool with which to begin. But beyond that, securing financial and political support was crucial to restoring the beaches and protecting the ocean and sea life from harm. Cindy Zipf decided she'd concentrate on a career using "science, law, and citizen action."

While living in an apartment above the hardware store in Sea Bright in 1984, Cindy Zipf's plan for action was born. When Cindy founded the coalition of concerned groups that became the COA, she was a staff of one.

Cindy Zipf of Clean Ocean Action and Dery Bennett of the American Littoral Society at a Beach Sweeps press conference in 1992. *Courtesy of Clean Ocean Action.*

The first benefit for COA was held at the Peninsula House, a former Sea Bright beach club that brings back fond memories for many locals.

The Beach Sweeps, "the largest grassroots environmental event in New Jersey," was organized and coordinated by Zipf and COA. It started in 1985 at Sandy Hook with 75 dedicated volunteers. Since then, more than 101,000 citizens have collected 5.2 million pieces of harmful marine debris. Twice a year, in the spring and fall, families, individuals and groups—people from all walks of life—show up with gloves and bags to comb the beaches for trash. Their finds are carefully tabulated, as collecting the data is essential. Each piece of debris is recorded and later compiled in an annual report that documents the type of litter and where it is found. Some of the most common offenders are plastic pieces, cigarette filters, straws/stirrers, soda bottles, candy wrappers and pieces of foam. You never know what's going to turn up, and COA's 2013 "Roster of the Ridiculous" includes such items as headphones, picket fencing, a toilet seat, a full-size refrigerator, dentures, rubber ducks and a Barbie doll. According to COA, "We've come a long way from the days of dead marine life, raw sewage, medical waste and garbage washing up on our beaches, ocean dumping of sewage sludge, acid waste, toxin laden muck, and many other harmful activities."

Since 1984, Cindy Zipf, with the help of a dedicated staff and volunteers, has mobilized diverse local organizations into action to help clean up and protect the waters of the New York Bight. The coalition includes environmental, religious, student, fishing, surfing, boating and diving groups, to name a few of these "Ocean Wavemakers."

The myriad accomplishments of COA over the years include shutting down ocean dumpsites and initiating federal laws to prohibit dumping noxious materials, such as sewage sludge, toxic mud, industrial waste and more. The organization has worked to pass a fertilizer law that reduces the amount of pollution in the major waterways from lawn care fertilizers sold at stores and regulates their use. It has also helped to avert major crises when industrial facilities and offshore drilling were proposed just off the coast. Zipf's organization also provides initiatives for students, inspiring them to work for a cleaner environment. (To learn more about COA, visit www.cleanoceanaction.org.)

COA focuses on pollution and the American Littoral Society on conservation, but the two organizations share common goals. Both operate headquarters in one of the historic officer's row houses at Fort Hancock, Sandy Hook. The building was spared during Sandy, but many of the other structures suffered severe damage from the superstorm.

Cindy, that inquisitive little girl who was fascinated by marine life, has never lost her youthful enthusiasm. She lights up when she says, "Now we have ospreys everywhere!" She has proven to be a remarkable woman by the sea who is constantly striving to do more. Most recently, she has been campaigning to stop the threat of seismic blasting off the New Jersey coast. Cindy Zipf thrives on the challenges she faces but would like to see the day when her job is not needed anymore.

A STRONG WOMAN AND THE SEA: DINA LONG

This is what I found behind the Borough Hall. It's a piece of Donovan's sign, and it says "DO" because "DO" is what we are going to do! We are going to rebuild our town sustainably for the future. Sea Bright is not gone. Sea Bright is its people. Sea Bright is you. We're Sea Bright...I mean the beach helps (the crowd laughs!)...As long as we are here and as long as we support each other, as long as we work together, we will get through this. We will DO!
—Mayor Dina Long at a Sea Bright town meeting held on the grounds of Rumson Fair Haven High School, November 1, 2012

Superstorm Sandy smacked the New Jersey coast with tremendous force on October 29, 2012, causing severe damage and widespread power outages. In the little town of Sea Bright, one of the hardest-hit communities of all, the mayor stepped up to meet the challenges of keeping the faith and dealing with the devastation. This remarkable woman, Mayor Dina Long, never abandoned her ship during or after the ordeal.

Mayor Long's first look at Sea Bright after the storm was one of disbelief. The town resembled a war zone. She needed to release her emotions when she beheld the mountains of sand that buried the streets, piles of rubble, cars and boats sticking up everywhere and battered buildings filled with seawater. But she quickly wiped away any tears and rolled up her sleeves; there was work to be done. With her long, dark brown hair and winning smile, Dina might look like a fairy tale princess, but she's really one tough cookie. She has never hesitated to put on waders and make her way through floodwater to comfort distressed residents and business owners of Sea Bright. Her waders even stay in her car. Living in a seashore town, you never know when they'll be needed. It's a way of life. But Sandy, more powerful than any previous

Dina Long, the mayor of Sea Bright, poses in front of a large mural by Jim Kovic on the side wall of a freshly painted building in her town in 2014. The artwork, representing a "Greetings from Sea Bright" postcard, depicts the town's history and attractions, including the old Peninsula House, which can be seen in the letters. Sea Bright was devastated by Superstorm Sandy in 2012 but has made remarkable progress. *Photo by author.*

storm, displaced all of Sea Bright's residents and destroyed 100 percent of its businesses.

Located on the southern half of a barrier beach known as the Sandy Hook Peninsula, Sea Bright is bordered by the Atlantic Ocean to the east and the Shrewsbury River to the west. Often called the "Gateway to the New Jersey Shore," the town is easily accessible from New York, which is only a little over an hour away. Sea Bright was incorporated in 1889, but even before that, the barrier beach was a fishing village called "Nauvoo." In the mid-nineteenth through the early twentieth centuries, visitors came by rail and by steamboat to sojourn at big summer "cottages" and stylish hotels. In recent decades, day-trippers and locals who enjoy the beaches, marinas, shops and restaurants are most prevalent.

Mayor Dina Long is a Jersey Shore girl who was born in Neptune in 1969 and went to St. Rose High School in Belmar. Throughout her childhood and teen years, she frolicked on the beaches of Belmar and other shore towns. Her favorite fictional character was "Brenda Starr, Reporter." She even went around with a little briefcase emulating the comic strip heroine. Dina's desire to be a reporter didn't diminish when she grew up. In 1987, she entered Rutgers University as a journalism major.

After landing an internship with the Office of Public Affairs in Governor James Florio's office, Dina decided to take time off from college and worked on Florio's 1993 campaign as an executive assistant to the finance director. During this time, she met Robert Long, who was the campaign treasurer. From 1994 to 1996, Dina worked as an event manager on Senator Bill Bradley's campaign staff.

In 1995, Dina and Robert were married. Dina received her degree from Rutgers the following year and went on to earn an MFA from the New School University in New York. In 2002, Robert Long, who had attended seminary school, took a position as pastor of the United Methodist Church in Sea Bright. Dina and Robert moved into a charming older home in the seaside community, and their son Sam was born in 2003. Robert remained a pastor until 2013, when he returned to a financial position. Dina worked various state-level political jobs and taught college English at several institutions. She took a full-time position in 2006 at Brookdale Community College in Lincroft, where she currently works as an assistant professor, teaching composition and literature.

From 2003 to 2011, Dina served as a Sea Bright councilwoman, and she was elected mayor in November 2011, defeating the incumbent office holder. As a speaker, she knows how to hold her audience's attention. In her 2012 greeting at the Sea Bright Reorganizational Meeting, she related the amusing story of how a woman named Rista came up to her and proclaimed, "I'm the only Hooker in town!" (Hooker is her surname.)

The volunteer position of mayor would keep Dina Long busy with one concern or another, but when Sandy came to town, she faced the biggest challenge of her career. Fortunately, a warning was issued five days before the storm so that Sea Bright residents, including Dina's family, could be evacuated and stores boarded up. And yet no one could have imagined how severe the destruction would be. At least no lives were lost.

When Mayor Long first entered Sea Bright with other officials and first responders after Sandy, the smell of gas prevailed. Anxious people waited, camping out by the Sea Bright Bridge, but could not be allowed back until their town was declared safe. On the third day after Sandy, a Sea Bright town meeting was held at Rumson Fair Haven High School, the largest nearby venue available. It was at this gathering with over one thousand people in the bleachers that Mayor Long held up the letters "DO" (part of a sign from what was left of Donovan's Reef, an oceanfront bar/restaurant). She had placed them in her pocket while surveying the debris. During Sandy and in its aftermath, communication was difficult, and Dina Long's lifeline was her

Twitter feed. It became not only a means of communication but her journal as well. She says, "Social media was the glue that held the community of Sea Bright together."

As the extent of the damage was sinking in, a concrete plan for Sea Bright went into place. When Governor Christie came to Sea Bright within a week after the storm, he went over every "to-do" item on Mayor Long's list with her. Volunteers and work crews from all over, local as well as out of state, came to the rescue. The National Guard was called in to help. Chris Wood, owner of Woody's restaurant, stepped up to feed the hungry workers, and a relief organization called Sea Bright Rising was formed. In early December, a celebration was held in Sea Bright, and the rock group Train played for the local crowd. The band volunteered after seeing an insightful video made by a teenager named Charlotte Nagy, who filmed Sea Bright before and after Sandy.

By the close of the 2014 summer season, almost two years after the storm, Sea Bright has made amazing progress. Streets are clear, the beach is busy, many stores and restaurants have reopened and new businesses are popping up. It's been a struggle for property owners to collect insurance, but they've persevered. Structures have been raised, and construction is continually going on to meet the standards required for rebuilding. A hotel is in the planning stages. Fresh coats of pastel paint cover the old buildings. There's nothing dismal about Sea Bright; the little town lives up to its name.

As Mayor Dina Long walks down the town's main street today, people smile and say hello. She's so proud of Sea Brighters, whom she says have "a ruggedness and fierce independence." These words also describe Dina Long. Currently unaffiliated with a political party, she's a woman who isn't obsessed with politics or fame. She's interested only in making a difference; she's a woman who can "DO."

Epilogue

"I LOVE LUCY!"

Lucy the Elephant, the celebrated pachyderm of Margate City, New Jersey, represents a strong female character that has become recognized as a symbol of the New Jersey Shore. Like so many of the women described in this book, she's survived hardships and storms. Lucy remained standing during the hurricane of 1944, the great storm of 1962 and even Superstorm Sandy in 2012! She even survived a fire in 1904 that was started by some "inebriated party-goers" when she was used as a tavern before Prohibition.

The sixty-five-foot wooden elephant (the name Lucy came later) was constructed in 1881 by real estate investor James V. Lafferty, who owned undeveloped lots in the booming area of South Atlantic City (now Margate City). He built the colossal animal to grab the attention of potential buyers. He escorted them up to the howdah on top of his six-story elephant so they could view the land. Lafferty even owned a patent on his structure's unique design.

In 1887, Anton Gertzen of Philadelphia purchased Lafferty's elephant. It was Sophia Gertzen, his daughter-in-law, who reportedly named the structure Lucy in 1902, and the name stuck. It is said that, at first, people thought of the elephant as male because of the tusks. Nevertheless, they took to calling her Lucy and gave her feminine traits. She was used for different purposes but never as a hotel, although the Elephant Hotel was right next to her for a number of years.

Perhaps the worst threat to Lucy's existence was during the 1960s, when she suffered from neglect. The decaying structure was about to be replaced by condos, but thanks to people who cared about her, she was saved. In 1970, the Save Lucy Committee raised enough money to have Lucy moved to a new location at the Margate beach, not far from her original spot.

An original cabinet photo of South Atlantic City's (now Margate City) Lucy the Elephant in the 1890s. *Author's collection.*

Personally, I remember Lucy from the 1950s, when I was a child and she was in sad shape. My grandparents spent their summers near Lucy's original location, and my cousin Skipper and I used to visit them. Of course, we loved the beach, and we were fascinated by Lucy. Typical curious kids, we ventured inside her. I'm not sure if we were supposed to, as I can't remember exactly. But I think perhaps you could simply wander around her then. I recall the peeling paint and the musty smell of rotting wood. And yet there was something exciting about being in Lucy's belly, a special place to hide from the rest of the world.

Some people might think it's wrong to be gender specific or to attribute anthropomorphic qualities to a structure. Others might feel it's frivolous to make a fuss over the decadent roadside attraction, a relic from another century. But most people need the stability of endearing artifacts and traditions of the past. In today's complex world, there is something comforting about this elderly elephant.

In 1976, Lucy was designated a national historic landmark, the oldest surviving example of "zoomorphic" architecture. Today, Lucy the Elephant stands beautifully restored in Josephine Harron Park (named for the co-founder of the Save Lucy Committee). Both tourists and locals take guided tours inside Lucy, where her memorabilia is displayed. They can climb a spiral staircase in one of her legs and enjoy the 360-degree view from her howdah. Lucy is the site of many events and charity fundraisers. The famous elephant even gets an annual "pedicure" when her toenails are painted in bright colors! I've been to see Lucy recently, and I can't wait to return. (For more about Lucy, visit her website at www.lucytheelephant.org.)

Lucy is strength. Lucy is whimsy. Lucy is the essence of the New Jersey Shore.

NOTES

INTRODUCTION

1. Oxenford, *People of Ocean County*.
2. Wikipedia, "Penelope Stout," http://en.wikipedia.org/wiki/Penelope_Stout.
3. Beesley's Point is a site on the New Jersey Women's History Trail. The Ocean City chapter of the DAR was previously named for Sarah Stillwell, and the children's chapter of the Cape May CAR is named for Rebecca.

CHAPTER 1

4. MacKenzie, *Fisheries of Raritan Bay*, 35.
5. Ibid., 95–96.
6. Ibid., 168.
7. Ibid.
8. Oxenford, *People of Ocean County*, 59.
9. The Hurley Conklin Award is "presented to people who have lived in the Barnegat Bay Tradition." This award has been named in honor of the last of the Great Old Time Barnegat Bay carvers, Hurley Conklin. (Source: *Old Time Barnegat Bay Decoy & Gunning Show* magazine—with thanks to the Tuckerton Seaport Museum.)
10. *Ocean County Decoy & Duck Gunning Show* magazine, 2013, 37.
11. Sarah Patterson to her father, John C. Patterson, at the family farm in Adelphia, Howell Township, Monmouth County, May 7, 1865.
12. Mary T. Rasa, "Service to the Sea," http://www.gardenstatelegacy.com/files/Service_to_the-Sea_Rasa_GSL20.pdf.
13. Ibid.
14. J.P. Hand, "The Cape May Mitten Trade: Benjamin Franklin's Contribution to the Colonial Economy of the Jersey Cape," *Cape May County Magazine of History and Genealogy* 12, no. 2 (2010): 75–93.
15. Ibid.

16. Richard Degener, "Cape May Rediscovers Its Colonial Designer Fashion Chic," *Press of Atlantic City*, June 14, 2014.
17. John D. Christine, "West Cape May Gold Beaters," *Cape May County Magazine of History and Genealogy* 8, no. 4 (1984): 267.
18. Dorwart, *Cape May County*.
19. Christine, "West Cape May Gold Beaters," 267.
20. Ibid.
21. Sarah H. Bradford, *Harriet: The Moses of Her People* (Mineola, NY: Dover Publications, 2004), 44.
22. Wikipedia, "Harriet Tubman," http://en.wikipedia.org/wiki/Harriet_Tubman.

CHAPTER 2

23. Hesse, *All Summer Long*, 81
24. Levi and Eisenberg, *Atlantic City*, 100.
25. Meg Corcoran, "The Lifeguard," *Sun by the Sea*, unknown date.
26. Erik Larsen, "Jersey Roots: Belmar's 1st Girl Lifeguard Made a Splash," *Asbury Park Press*, June 19, 2014.
27. Ibid.
28. Interview with Suzanne Kaufer by Sandra Epstein, June 2014.
29. Gabrielan, *Monmouth Beach and Sea Bright*, 88.
30. Hesse, *All Summer Long*, 184.
31. Correspondence between Michael "Spike" Fowler and the author, 2014.
32. August 1, 2013 letter by Suzanne C. McCarthy, acting superintendent, National Park Service, Gateway National Recreation Area.
33. Gertrude Ederle in a 1992 letter published in King, *Stories from Highlands*.
34. http://www.visitmonmouth.com/oralhistory/bios/BahrsMae.htm.
35. Tim Dahlberg et al, *America's Girl* (New York: St. Martin's Press, 2009).
36. http://www.highlandsnj.com/gardenclub/Projects-Ederle.html.

CHAPTER 3

37. Karen Fox, "The Halls the Presidents Walked," *Cape May Magazine*, February 1, 2012.
38. Ibid.
39. Ibid.
40. Moss and Schnitzspahn, *Victorian Summers*, 84.
41. Works Progress Administration, *Entertaining a Nation*, 40.
42. Ibid.
43. In *Entertaining a Nation* (p. 178), there is a story about Guiteau visiting the St. James Church in Long Branch. Supposedly, he planned to shoot through a window across from the president's pew, but "two ladies blocked his view." This location is incorrect. Guiteau was not in Long Branch. This happened at a church in Washington, D.C. (I have confirmed this with Alan Gephardt, interpreter for the NPS at the Garfield National Historic Site in Ohio.)

44. Railroad ties from the spur were used to make the "Garfield Hut," built by nineteenth-century actor Oliver Byron as a teahouse. The hut was moved several times and stands today on the grounds of the Church of the Presidents in Elberon.

CHAPTER 4

45. Sarah J. Corson Downs, from an address in 1890. Quoted in Karnoutsos, *New Jersey Women*, 73.
46. Graw, *Life of Mrs. S.J.C. Downs*, 56.
47. Ibid.
48. Ibid., 148.
49. Ibid., 134.
50. *Historical Society of Ocean Grove Newsletter* 46, no. 87 (Spring 2014).
51. www.oceangrovehistory.org/WomansTrail.html.
52. From a circa 1950s letter to Walter Lord, author of *A Night to Remember*. Reprinted in Bryceson, *Elizabeth Nye*, 115.
53. The Salvation Army is a Christian denominational church that was founded in 1865 by William Booth, formerly a Methodist Reform Church minister, and his wife, Catherine. Salvationists are deeply involved with charity work.
54. Dr. Mace speaking at a 1929 dinner given in her honor at North Wildwood.
55. Barbara St. Clair, "Reflections: Margaret Mace: The Early Years," newspaper article (date and publication unknown) in the archives of the Wildwood Historical Society.
56. According to Wikipedia, the Women's Medical College of Pennsylvania, founded in 1850, was "the first medical institution in the world established to train women in medicine and offer them the M.D. degree." It was renamed the Medical College of Pennsylvania in 1970 when it began to admit men. In 1993, it merged with Hahnemann Medical School, and in 2003, the two colleges were absorbed by the Drexel University College of Medicine.
57. *Wildwood Leader*, "A Snowy Night in '35 Recalled," April 4, 1974.
58. Ibid.
59. Hancock, *Lady in the Navy*, 266.
60. Ibid., 9
61. Ibid., 12.
62. http://www.arlingtoncemetery.net/jblhofstie.htm.
63. http://www.womensmemorial.org/H&C/History/hancock.html.
64. Ibid.
65. Women's Project of New Jersey Inc., *Past and Promise*, 310.
66. http://www.womensmemorial.org/H&C/History/hancock.html.
67. Women's Project of New Jersey Inc., *Past and Promise*, 310.
68. Ibid.
69. Ibid., 265
70. Ibid., 267

CHAPTER 5

71. Maggie Mitchell as Fanchon in *Fanchon, the Cricket* (1862), Act I.

72. Julian Mitchell's parentage is unclear. He is usually said to be Maggie's half nephew, but some sources refer to him as her son.

73. Frederic E. McKay and Charles E.L. Wingate, eds., *Famous American Actors of Today* (New York: Thomas Y. Crowell & Company, 1896), 320.

74. Oxenford, *People of Ocean County*, 99.

75. Pedersen, *Jersey Shore Impressionists*, 25.

76. Ibid., 26

77. Ibid.

78. Oxenford, *People of Ocean County*, 100.

79. Ibid., 27.

80. Today, Osborn Island's official name is Niensdt Island.

81. Peter Lucia, "Asbury Park, Life Stimulus for Author," *Asbury Park Press*, October 2, 1995.

82. *The Editor* 48 (1918): 59.

83. Ibid.

84. King Neptune was portrayed by Hudson Maxim, who is said to be the inventor of gunpowder.

85. Roberts and Youmans, *Down the Jersey Shore*, 91.

86. www.missamerica.org.

87. Ray Schweibert, "Miss'd America Returning; Big Gay Ball to Debut," *Press of Atlantic City*, September 11, 2014.

88. Bill Kent, "The Horse Was in Charge," *New York Times*, May 4, 1997.

89. Marion Hackney obituary, clipping from unknown newspaper (1978) from the archives of the Atlantic City Free Public Library.

90. *Asbury Park Press*, "Remember When…," letter from Olive G. Stone, Interlachen, Florida, July 30, 1991, B5.

91. Jim Waltzer, "Waltz Through Time," *Atlantic City Weekly*, July 28, 2005.

92. Christopher Cook Gilmore, "The Last Dive," *Atlantic City Magazine*, June 1986.

93. Ibid.

94. http://www.ecology.com/2012/02/29/steel-piers-diving-horse-dives-history.

95. Jennifer Bogdan, "Plan to Bring Diving Horse Act Back to Steel Pier Draws Criticism from Animal-Rights Activists," *Press of Atlantic City*, February 2, 2012.

96. *Asbury Park Press*, "Remember When…," letter by Eleanore Wysocki (as told to her granddaughter Marilyn Joyce), July 30, 1991, B5.

97. http://m.imdb.com/name/nm0000038/quotes.

98. Roberts and Youmans, *Down the Jersey Shore*, 67.

99. Wikipedia, "Grace Kelly," http://en.wikipedia.org/wiki/Grace_Kelly.

100. Ibid.

101. Linda R. Marx, "Grace Kelly of Philadelphia," *People*, September 5, 1983.

102. Marjorie Preston, "The Princess of Atlantic City," *Atlantic City Weekly*, July 6, 2006.

103. Wikipedia, "Grace Kelly."

104. http://www.biography.com/people/grace-kelly-9362226.

105. Marx, "Grace Kelly of Philadelphia."

106. Wikipedia, "Grace Kelly."

107. Michener Art Museum, "Discovering Grace: The Kellys at the Shore: Ocean City, New Jersey," http://learn.michenerartmuseum.org/2013/09/discovering-grace-the-kellys-at-the-shore-ocean-city-new-jersey.

108. Ibid.

109. Bonnie Siegler, "Who's The Boss?" *Monmouth Health & Life* (March–April 2006): 24.

110. Wikipedia, "Patti Scialfa," http://en.wikipedia.org/wiki/Patti_Scialfa.

111. Susan Schindehette and Victoria Balfour, "Romancing the Boss," *People*, October 10, 1988.

112. Wikipedia, "Patti Scialfa."

113. Ibid.

114. Ibid.

115. Nj.com, "Bruce Springsteen's Son Sam Becomes Firefighter, Joins Colts Neck Fire Department," January 22, 2014.

116. Bruce Springsteen, "4th of July, Asbury Park (Sandy)."

117. *Asbury Park Press*, May 4, 2008.

118. Ibid.

119. Ibid.

120. http://www.stardem.com/obituaries/article_5b0d329c-4155-5f2d-9c4e-47a2e51ac161.html.

121. *Asbury Park Press*, May 4, 2008.

122. Wikipedia, "Marie Castello," http://en.wikipedia.org/wiki/Marie_Castello.

123. www.brucespringsteen.net.

Chapter 6

124. Wallace McKelvey, "Sara Spencer Washington Sparked a Boom in Black Hair Salons and Beauty Products," *Press of Atlantic City*, March 23, 2012.

125. Ibid.

126. Darlene Clark Hine, ed., *Black Women in America* (New York: Oxford University Press, 2005) 3:330.

127. http://www.njstatelib.org/slic_files/imported/NJ_Information/Digital_Collections/Afro-Americans/AFAMG.pdf.

128. Atlantic City Free Public Library, "The Atlantic City Experience."

129. Correspondence between the author and Royston Scott, 2014.

130. *Time*, May 17, 1937.

131. Dorwart, *Cape May County*, 211

132. Miscellaneous clippings in scrapbooks at the Wildwood Historical Museum.

133. *Time*, May 17, 1937.

134. Dorwart, *Cape May County*, 212.

135. Jacob Schaad Jr., "In Another Time: Bobby Rydell Has the Most Success with Wildwood Song," *Wildwood Leader*, January 18, 2011.

136. Warren E. Bradway, personal essay in the archives of the George F. Boyer Museum, Wildwood Historical Society.
137. Ibid.

Selected Bibliography

Books

Bryceson, David. *Elizabeth Nye: Titanic Survivor*. N.p.: Streets Publishers, 2009.

Dorwart, Jeffery M. *Cape May County, New Jersey*. New Brunswick, NJ: Rutgers University Press, 1992.

Foster, Feather Schwartz. *The First Ladies from Martha Washington to Mamie Eisenhower*. Naperville, OH: Cumberland House, 2011.

Fowler, Michael "Spike," Bernard A. Olsen and Edward "Ted" Olsen. *Lifeguards of the Jersey Shore*. Atglen, PA: Schiffer Publishing, 2010.

Gabrielan, Randall. *Monmouth Beach and Sea Bright*. Dover, NH: Arcadia, 1998.

Grant, Julia Dent. *The Personal Memoirs of Julia Dent Grant*. Edited by John Y. Simon. Carbondale and Edwardsville: Southern Illinois University Press, 1975.

Graw, Reverend J.B., ed. *Life of Mrs. S.J.C. Downs; or, Ten Years at the Head of the Woman's Christian Temperance Union of New Jersey*. Camden, NJ: Gazette Printing and Publishing House, 1892.

Hancock, Joy Bright. *Lady in the Navy: A Personal Reminiscence*. Annapolis, MD: Naval Institute Press (Bluejacket Books), 1972.

Hesse, Gordon. *All Summer Long: Tales and Lore of Lifeguarding on the Atlantic*. Bay Head, NJ: Jersey Shore Publications, 2005.

Johnson, Nelson. *The Northside: African Americans and the Creation of Atlantic City*. Medford, NJ: Plexus Publishing, 2010.

Karnoutsos, Carmela Ascolese. *New Jersey Women: A History of Their Status, Roles, and Images*. Trenton, NJ: New Jersey Historical Commission, 1997.

King, John P., ed. *Stories from Highlands, New Jersey: A Sea of Memories*. Charleston, SC: The History Press, 2012.

Larkin, Cheryl, and Kate Kurelja. *Savoring the Shore*. Denville, NJ: The Savoring the Shore Project, 2013.

Leibowitz, Steve. *Steel Pier: Atlantic City Showplace of the Nation*. West Creek, NJ: Down the Shore Publishing, 2009.

SELECTED BIBLIOGRAPHY

Levi, Vicki Gold, and Lee Eisenberg. *Atlantic City: 125 Years of Ocean Madness*. Berkeley, CA: Ten Speed Press, 1979.

MacKenzie, Clyde L., Jr. *The Fisheries of Raritan Bay*. New Brunswick, NJ: Rutgers University Press, 1992.

Moss, George H., and Karen L. Schnitzspahn. *Victorian Summers at the Grand Hotels of Long Branch, New Jersey*. N.p.: Ploughshare Press, 2000.

Oxenford, David D. *The People of Ocean County*. Point Pleasant, NJ: Valente Publishing House Inc., 1992.

Pederson, Roy. *Jersey Shore Impressionists*. West Creek NJ: Down the Shore Publishing, 2013.

Roberts, Russell, and Rich Youmans. *Down the Jersey Shore*. New Brunswick, NJ: Rutgers University Press, 1993.

Schnitzspahn, Karen L. *The Roaring '20s at the Jersey Shore*. Atglen PA: Schiffer Publishing, 2009.

———. *Stars of the New Jersey Shore*. Atglen, PA: Schiffer Publishing, 2007.

Stout, Glenn. *Young Woman and the Sea: How Trudy Ederle Conquered the English Channel and Inspired the World*. Boston: Houghton Mifflin Harcourt, 2009.

Waltzer, Jim, and Tom Wilk. *Tales of South Jersey: Profiles and Personalities*. New Brunswick, NJ: Rutgers University Press, 2001.

The Women's Project of New Jersey Inc. *Past and Promise: Lives of New Jersey Women*. Syracuse, NY: Syracuse University Press, 1997.

Works Progress Administration. *Entertaining a Nation: The Career of Long Branch*. Bayonne, NJ: Jersey Printing Co., 1940.

INTERNET RESOURCES

Atlantic City Free Public Library. www.acfpl.org.

Atlantic County Women's Hall of Fame. www.acwhf.org

National Women's History Museum. www.nwhm.org.

New Jersey State Federation of Women's Clubs. www.njsfw.org.

New Jersey Women's History. www.njwomenshistory.org.

New Jersey Women's Heritage Trail. www.njwomenshistory.org/nj-womens-heritage-trail.

PERIODICALS

Asbury Park Press	*New York Times*
Atlantic City Weekly	*Press of Atlantic City*
Beachcomber	*Star Ledger*
Cape May Times	*Sun by the Sea*

INTERVIEWS BY THE AUTHOR

Karyn Jarmer, July 16, 2014.

Doris Pflug Jernee, July 11, 2014.

Vicki Gold Levi, June 20, 2014.

Dina Long, Mayor of Sea Bright, August 1, 2014.

Dale Parsons, Parsons Seafood, August 7, 2014.

Cindy Zipf, Clean Ocean Action, July 30, 2014.

INDEX

INDEX

About the Author

Author Karen L. Schnitzspahn with Lucy the Elephant in Margate City, 2014. *Photo by Leon Schnitzspahn.*

For over twenty-five years, Karen L. Schnitzspahn has been writing and researching about the history of the New Jersey Shore, where she lives. Born in New Brunswick, New Jersey, she is proud to be a "Jersey girl." Karen is the author or coauthor of ten regional New Jersey books, including *Jersey Shore Food History: Victorian Feasts to Boardwalk Treats* (The History Press, 2012). She's been the recipient of awards such as the 2007 Jane G. Clayton Award for "her outstanding efforts to preserve the history of Monmouth County." Her varied interests include the history of the American theater and the art of puppetry. For many years, Karen worked as a professional puppeteer and designed educational children's programs.